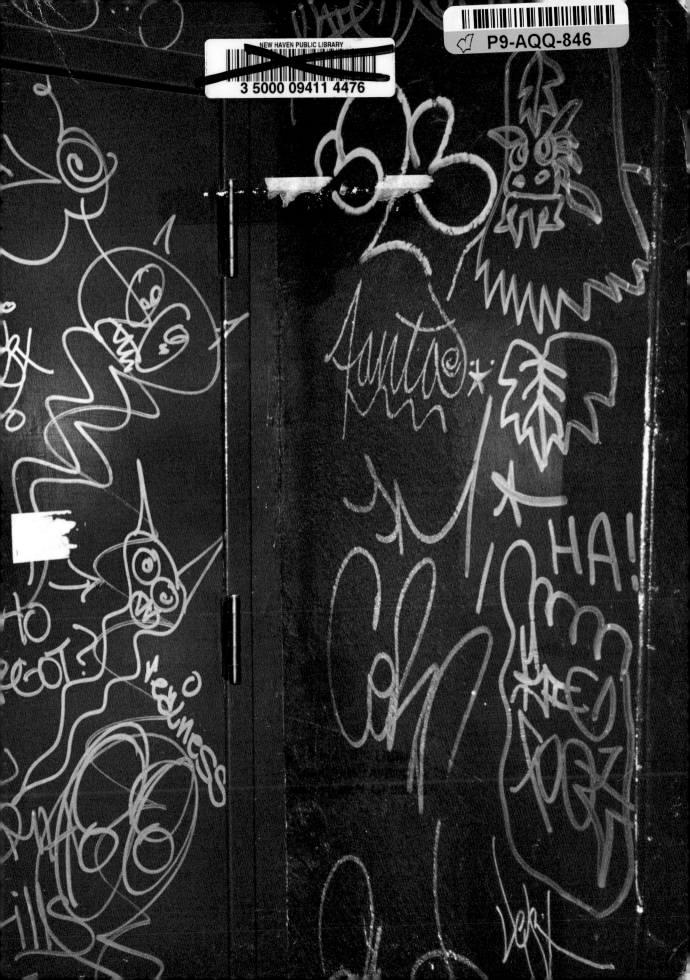

AUTOGRAF

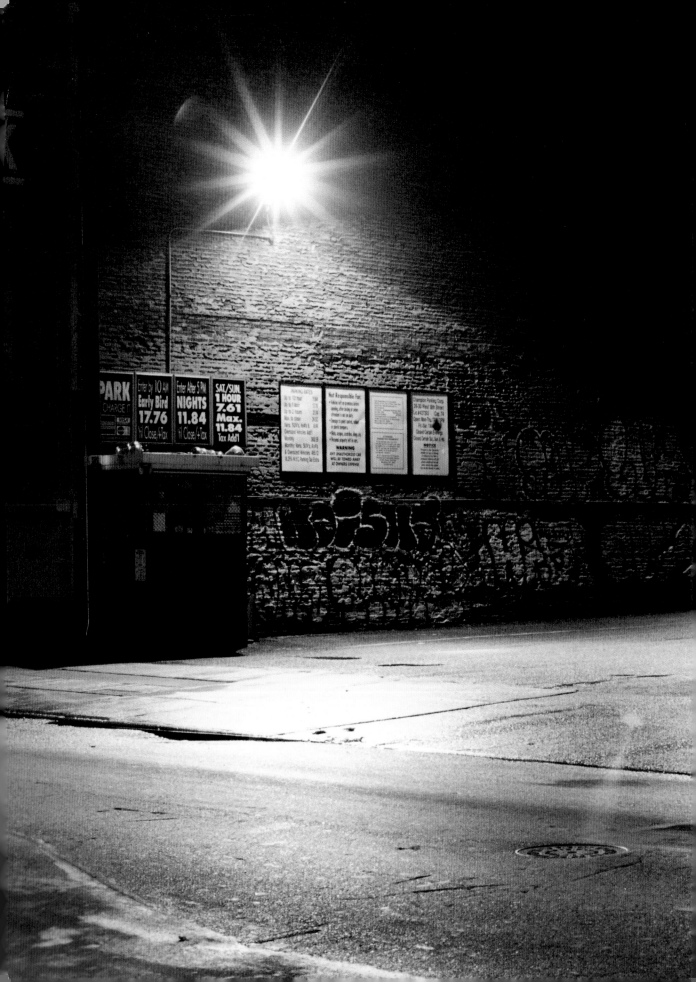

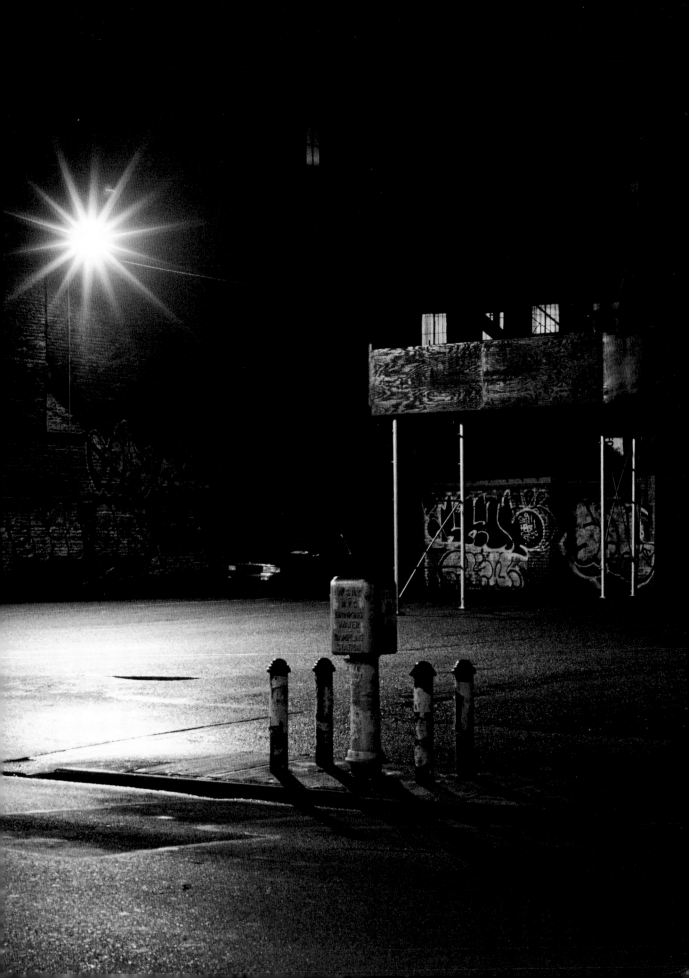

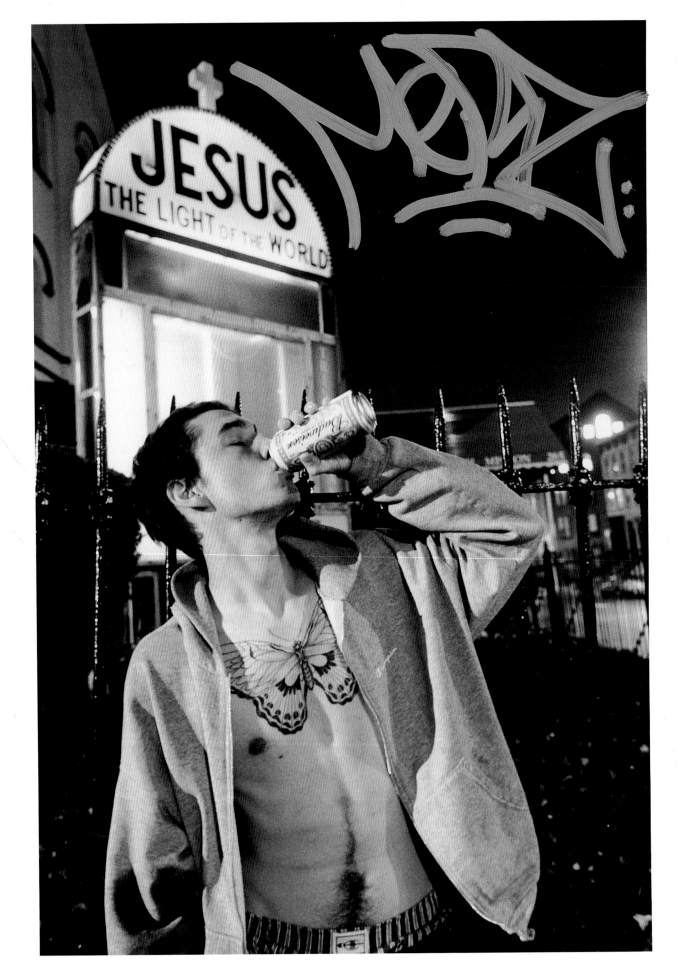

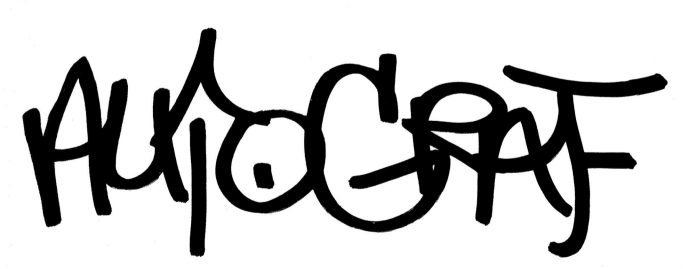

AUTOGRAF: NEW YORK CITY'S GRAFFITI WRITERS BY PETER SUTHERLAND

Text by REVS

 powerHouse Books New York, NY

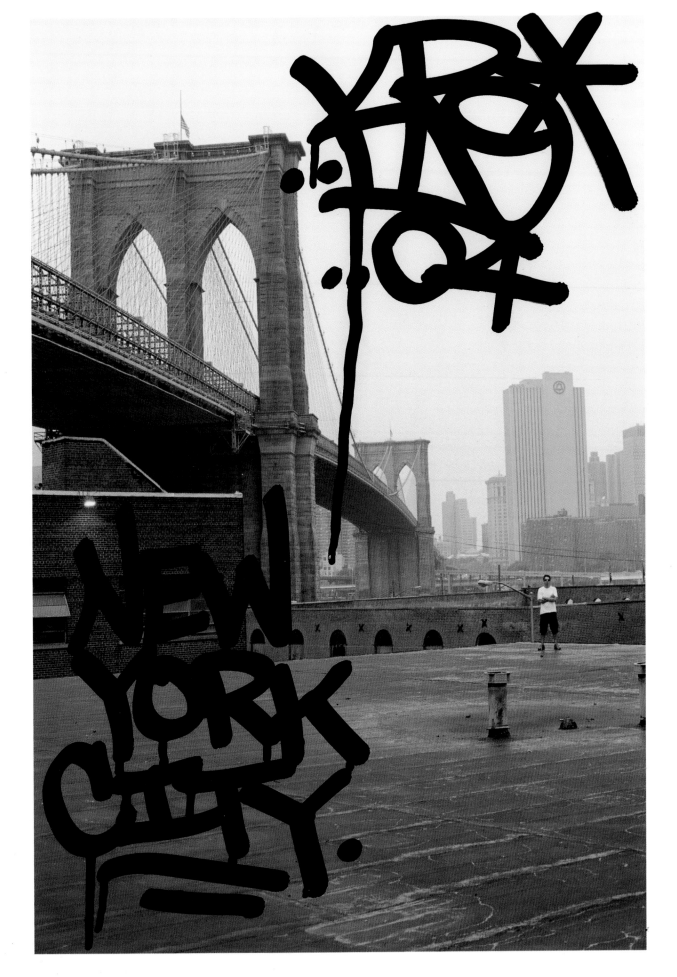

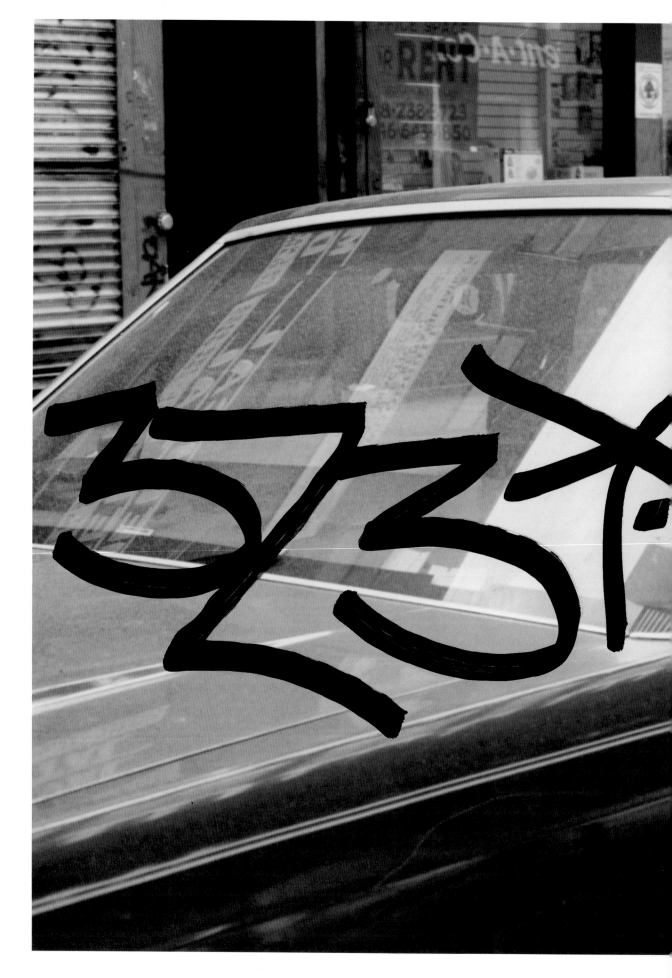

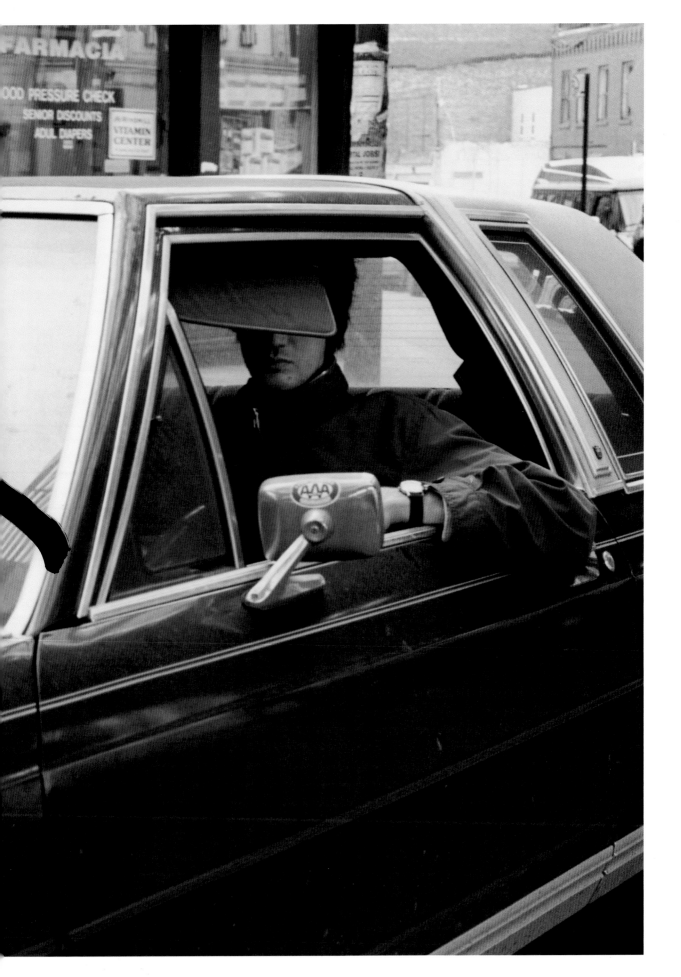

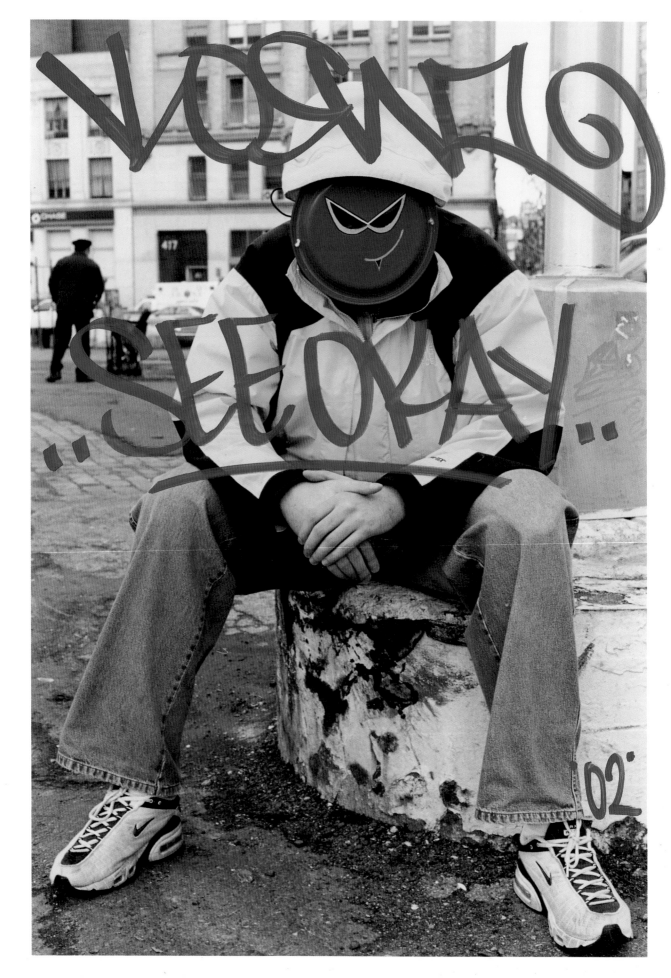

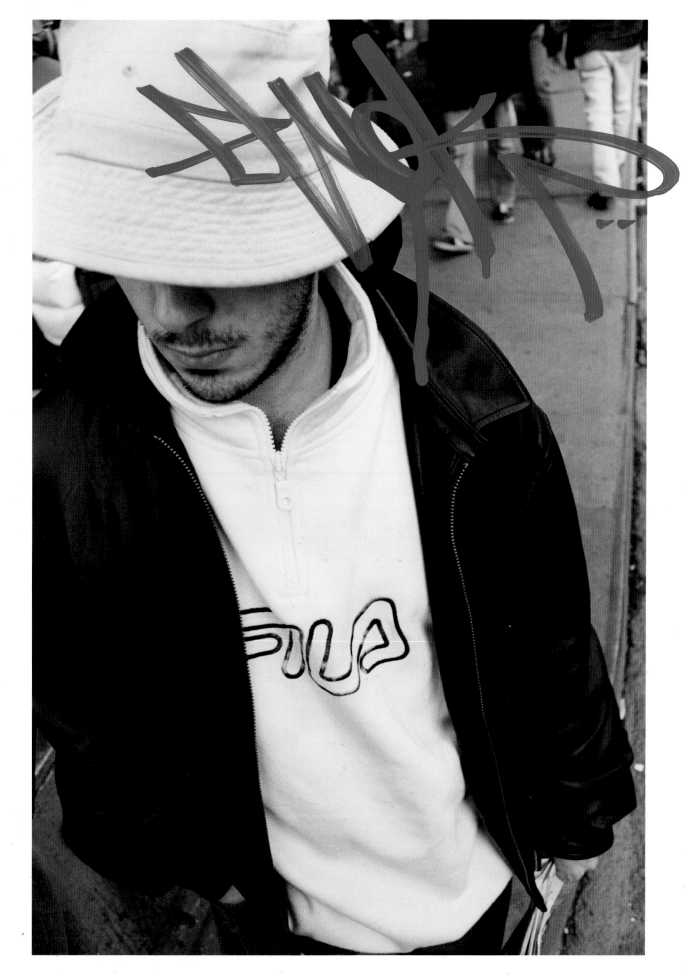

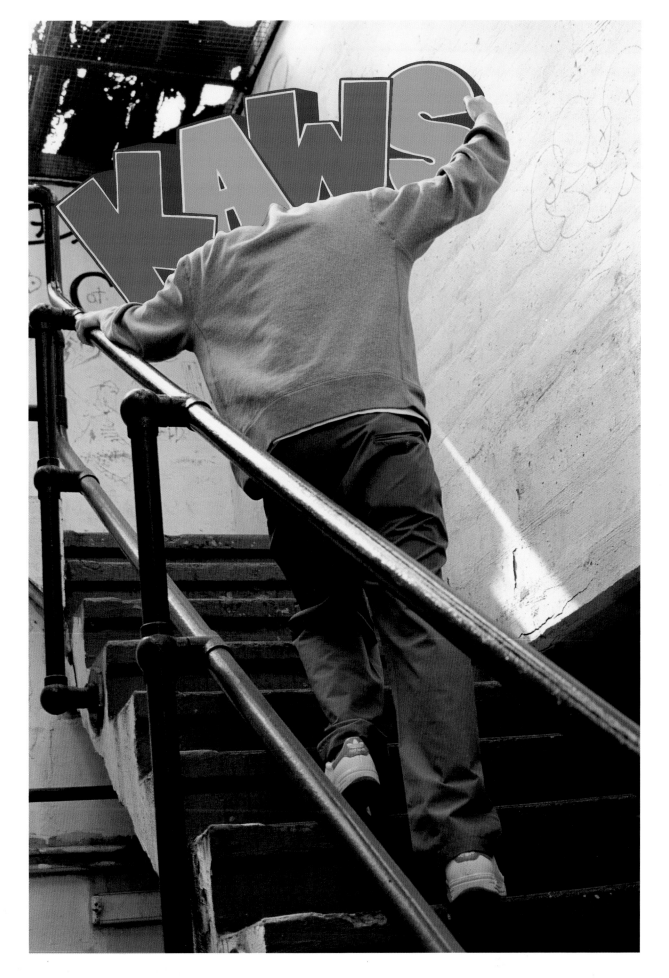

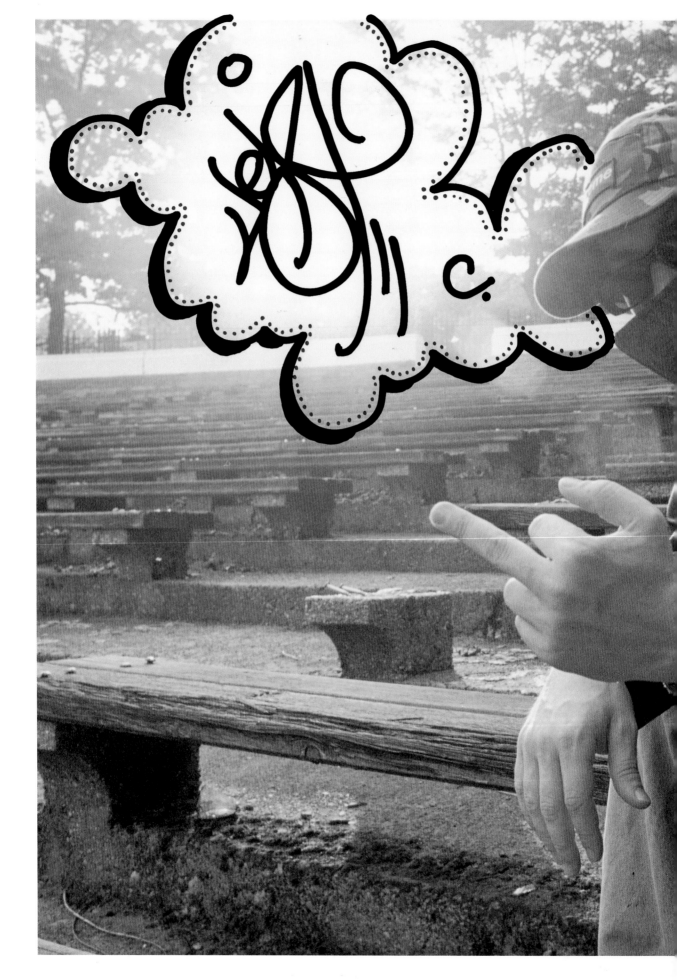

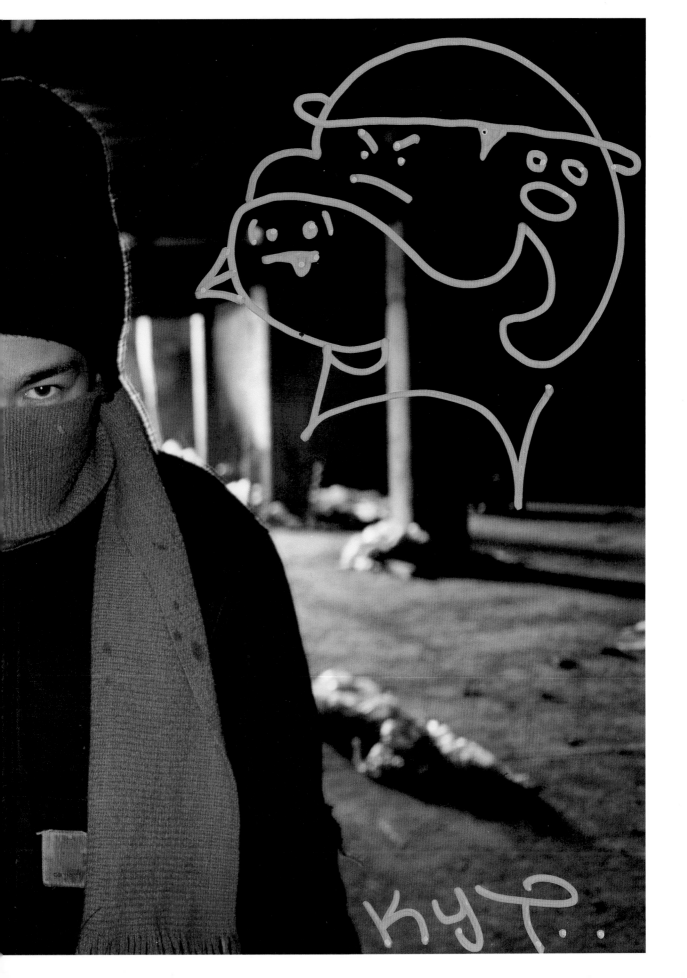

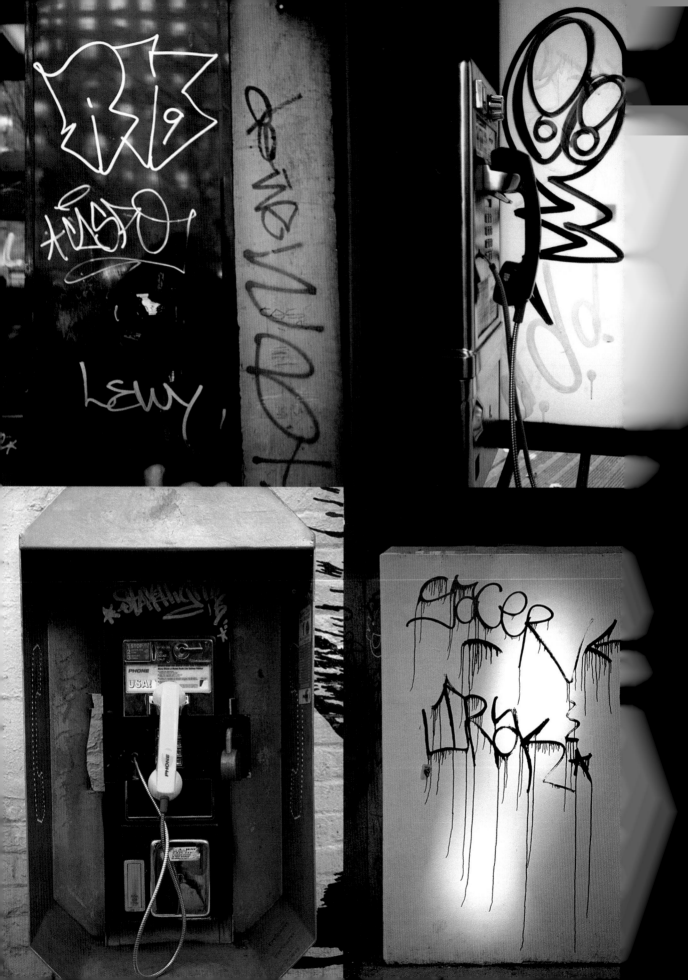

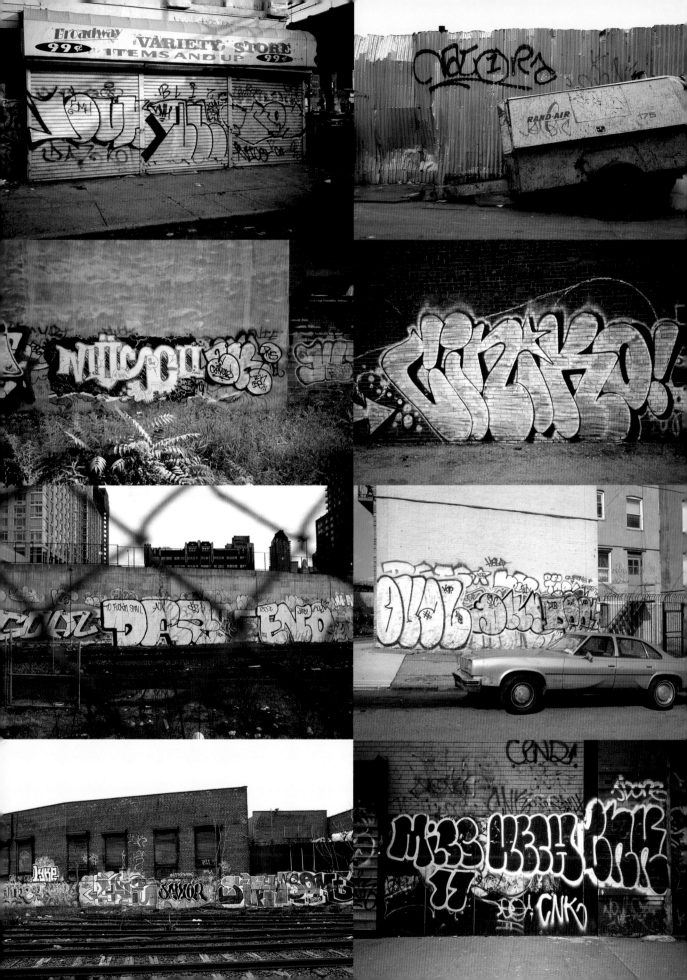

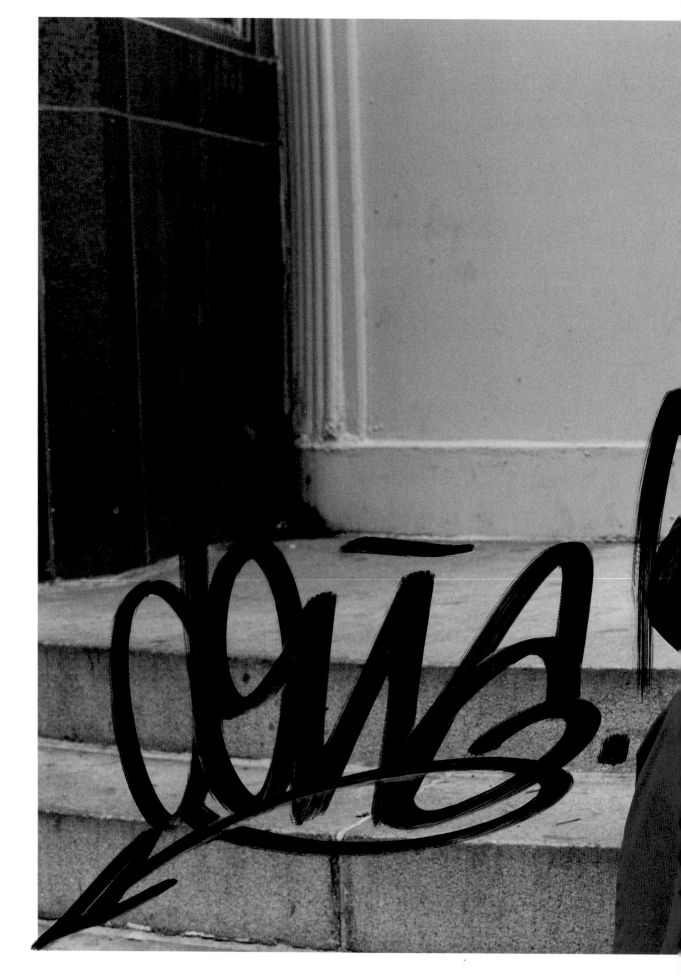

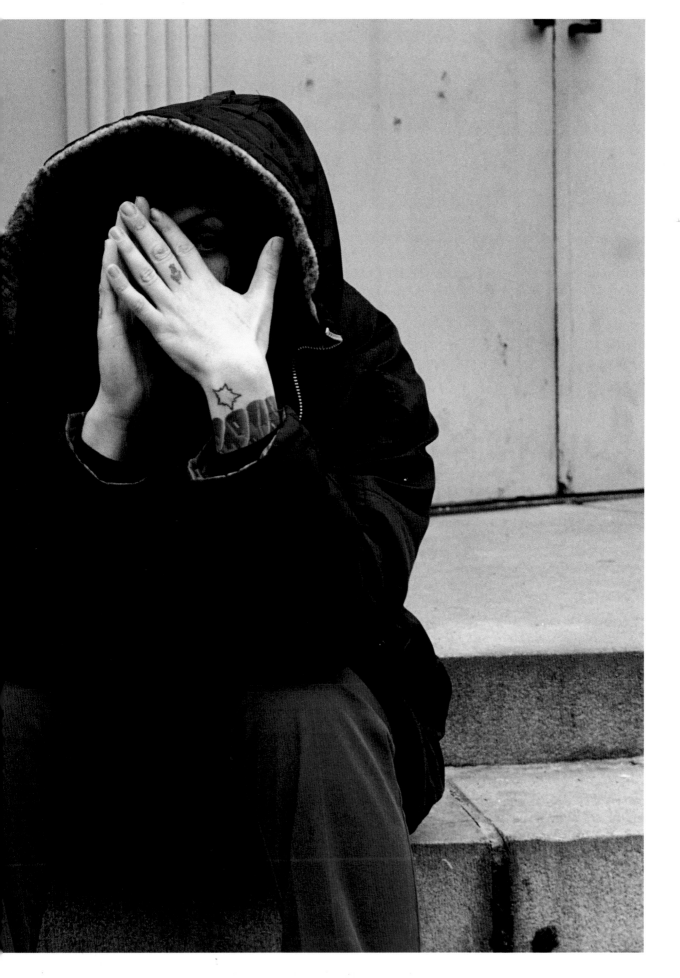

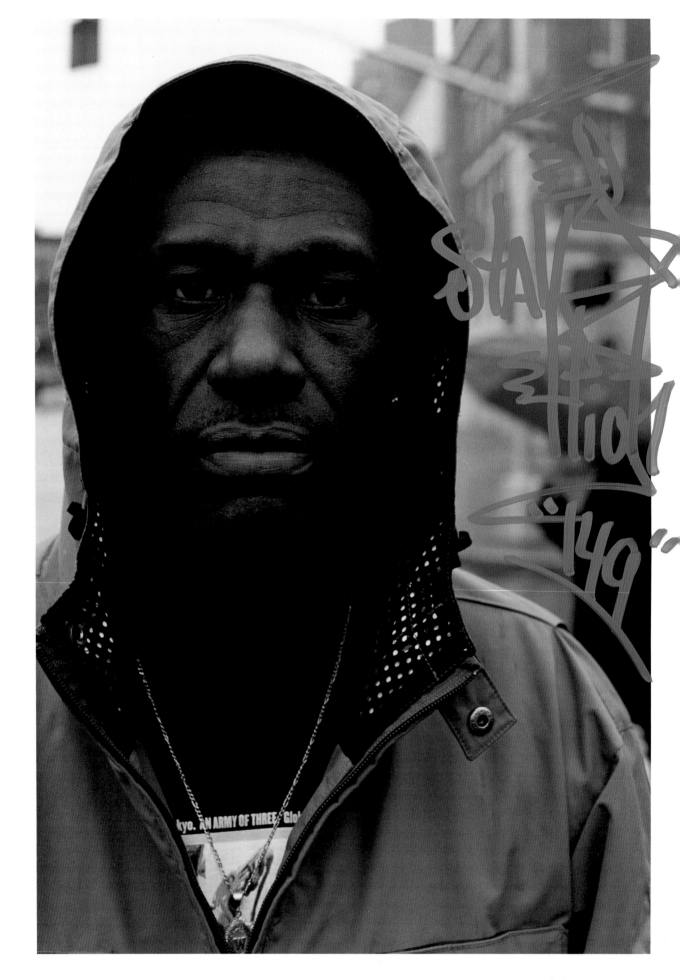

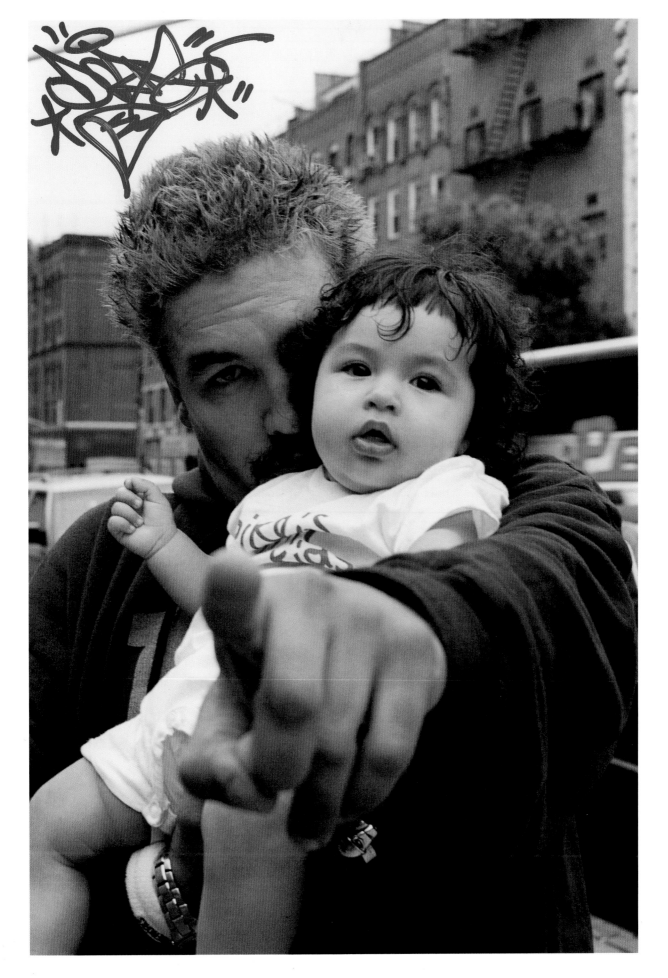

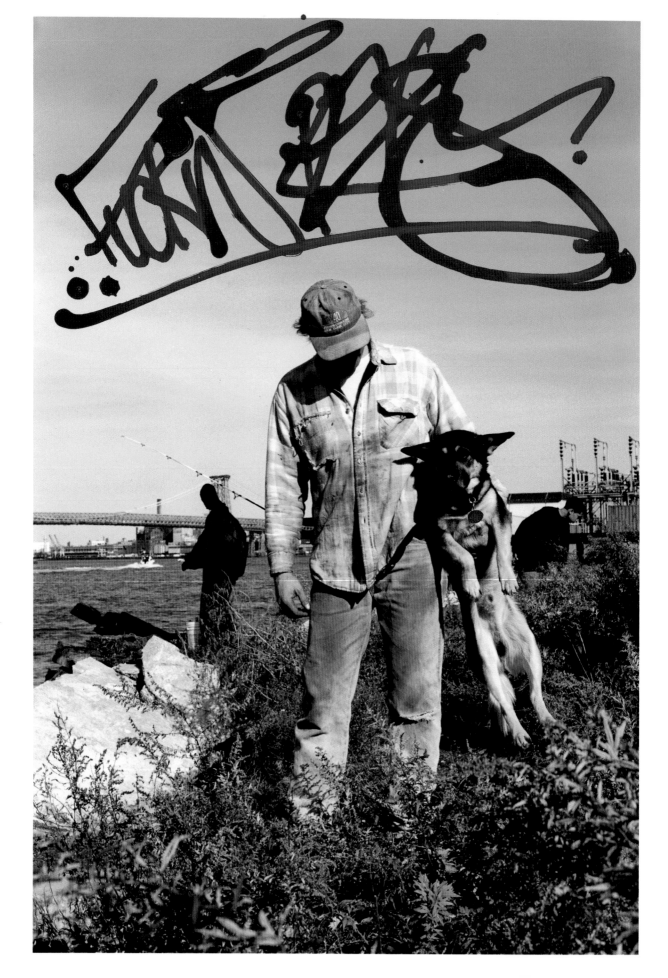

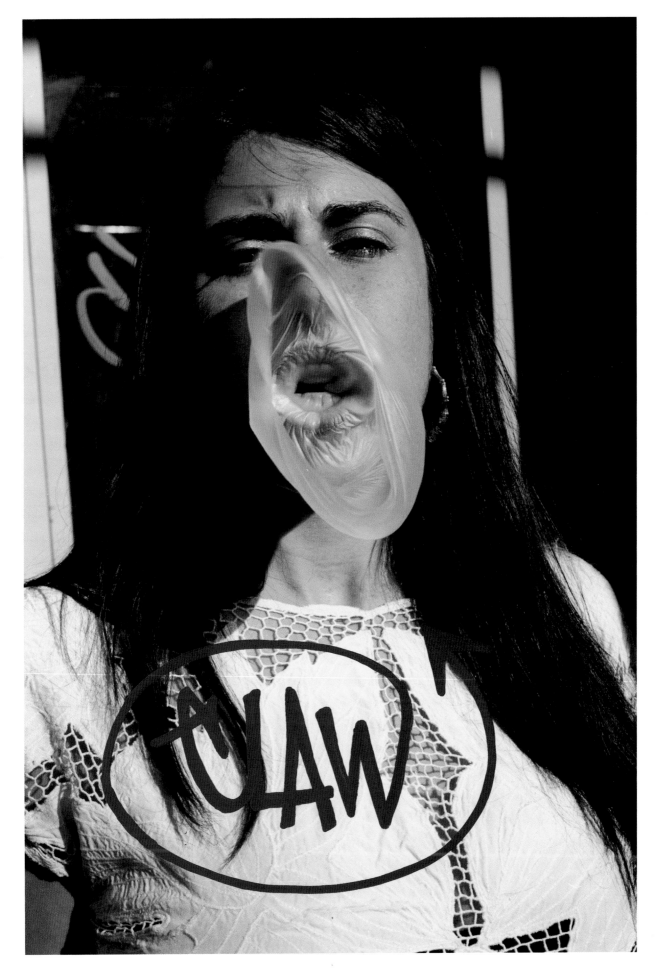

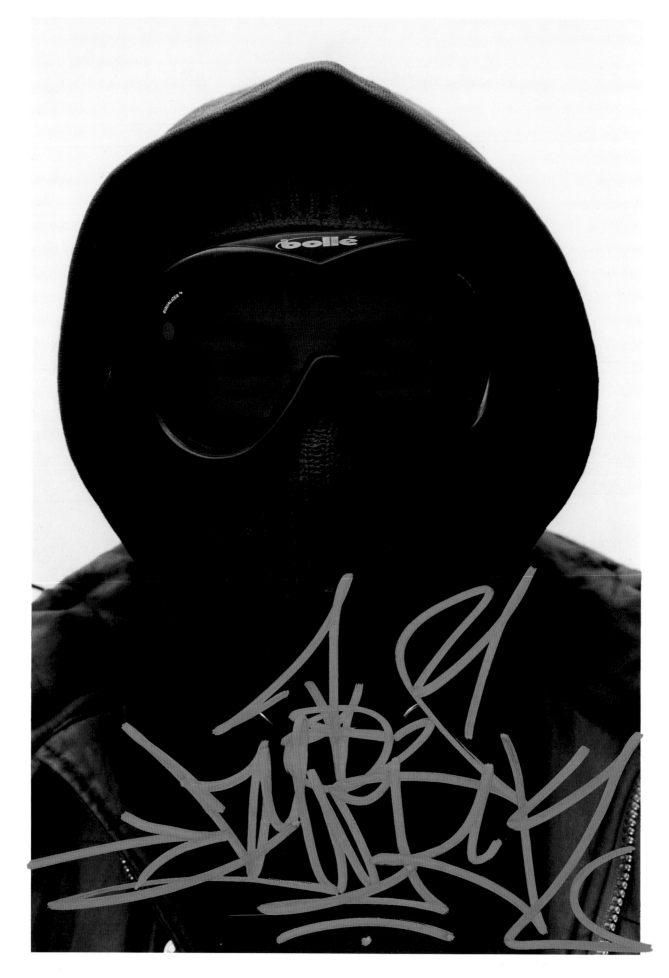

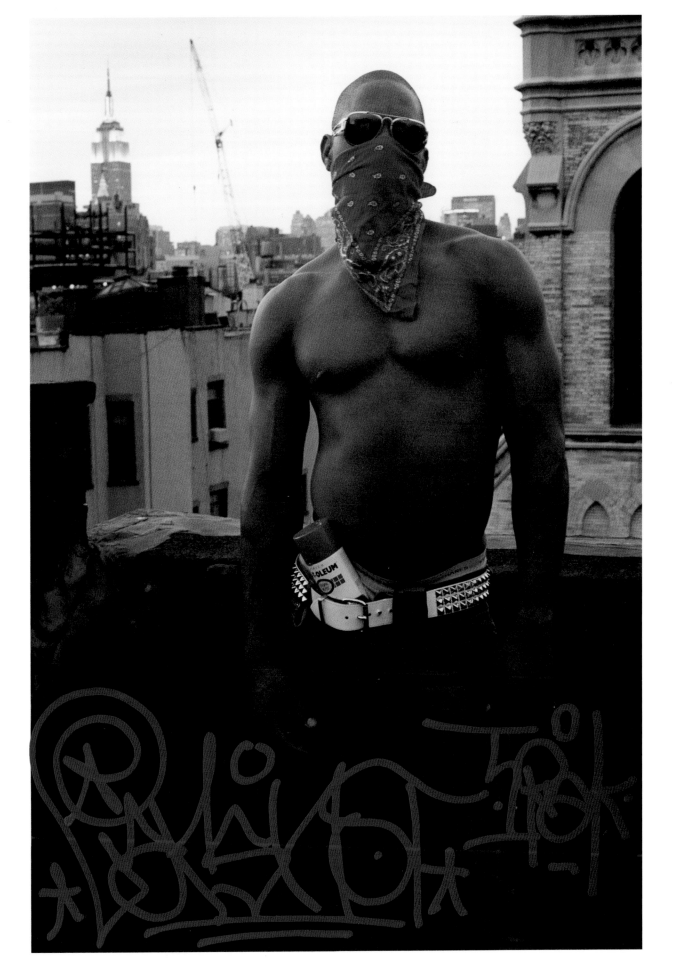

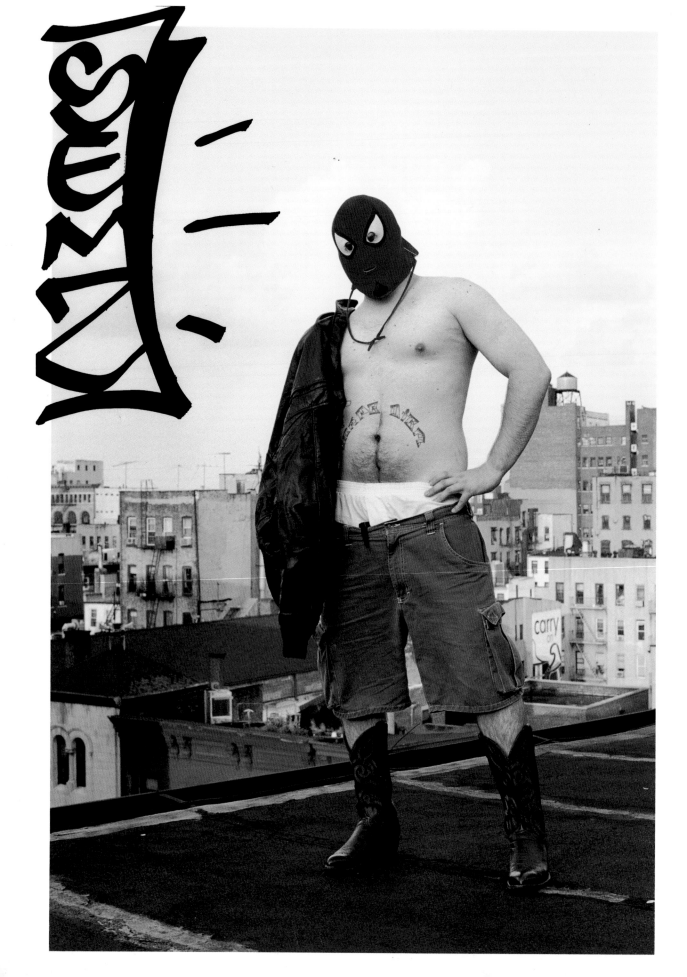

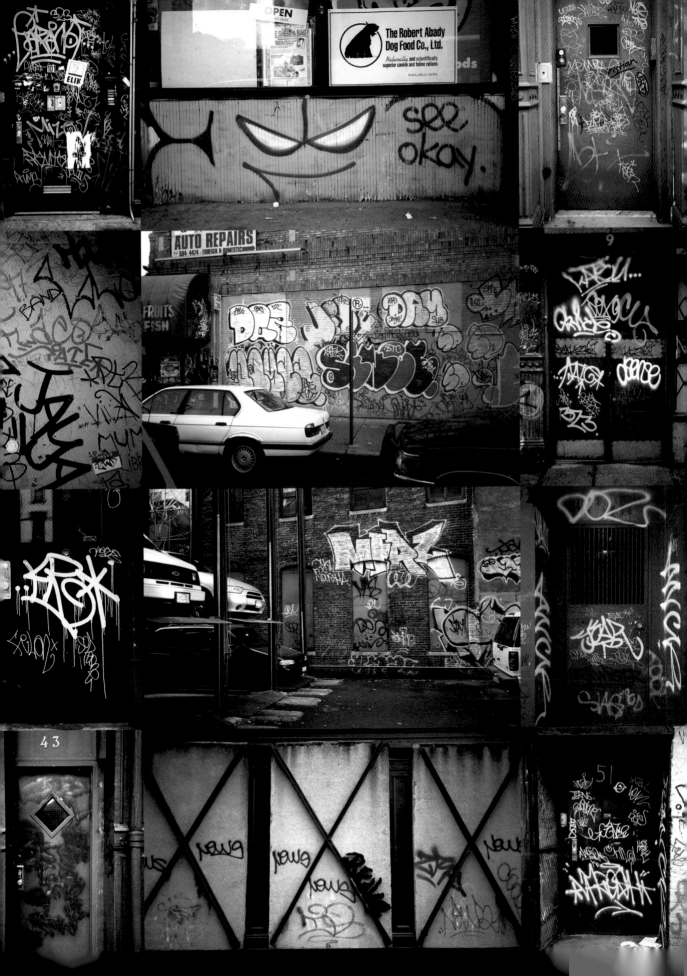

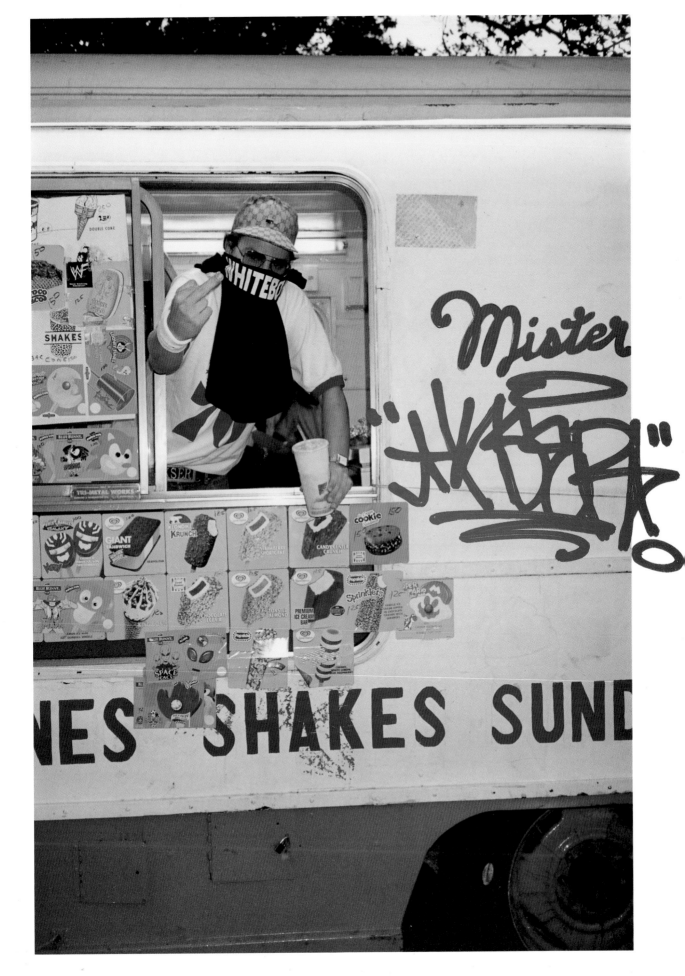

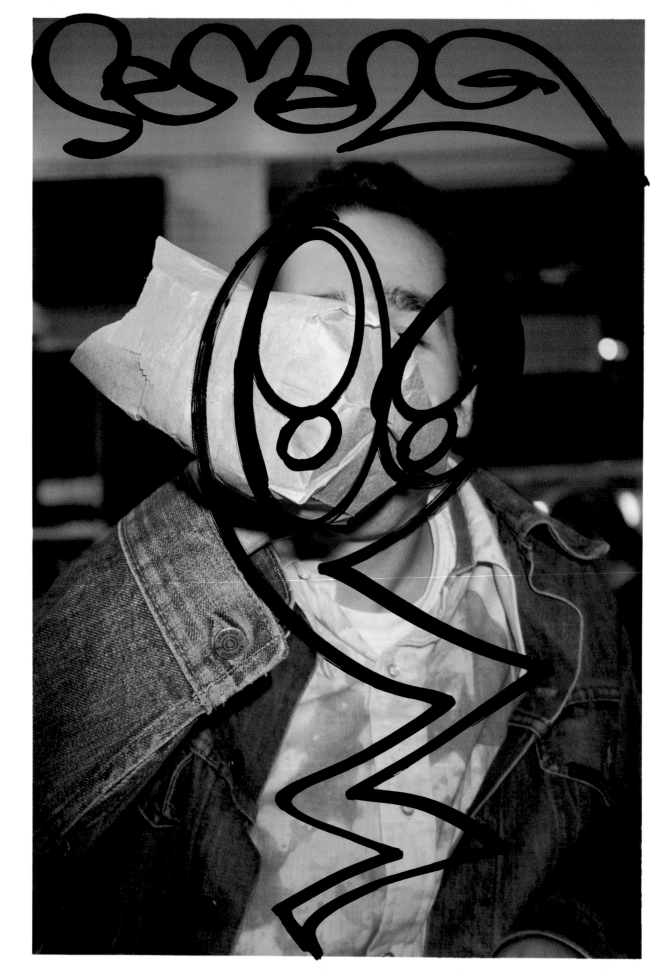

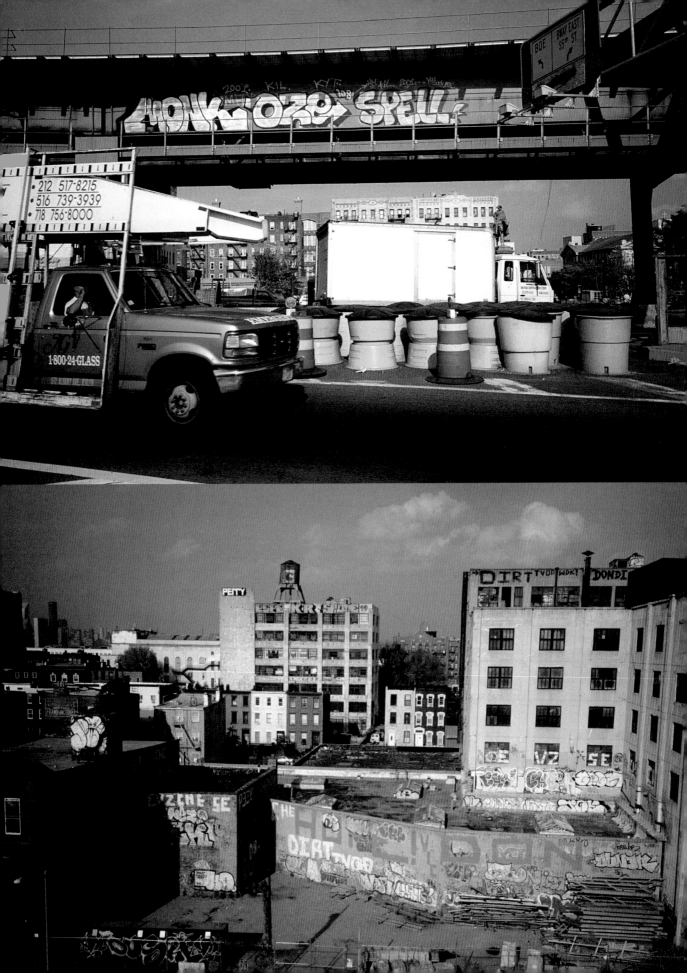

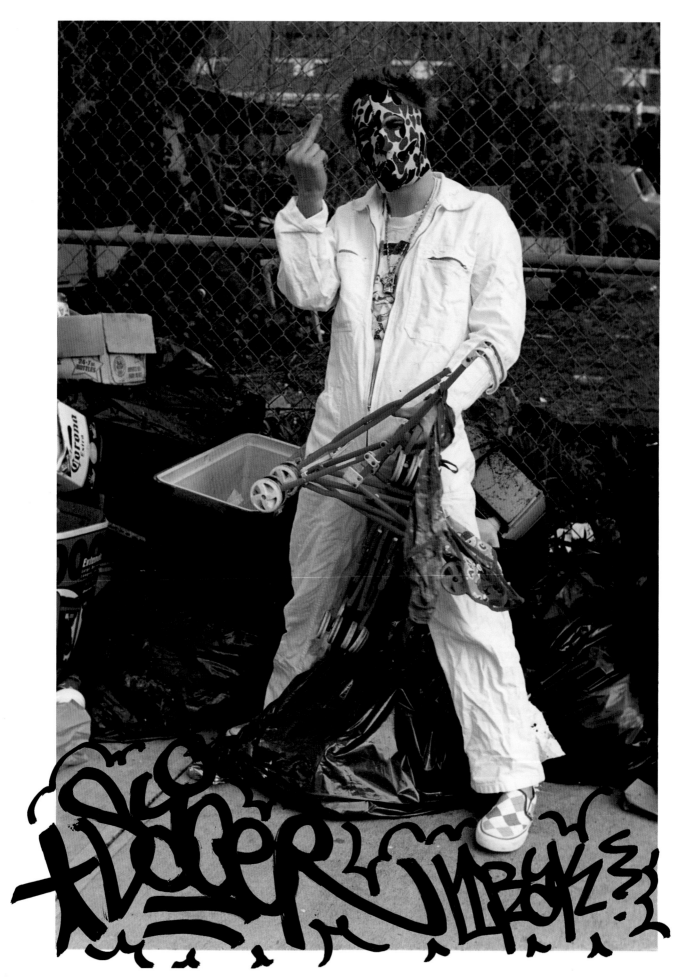

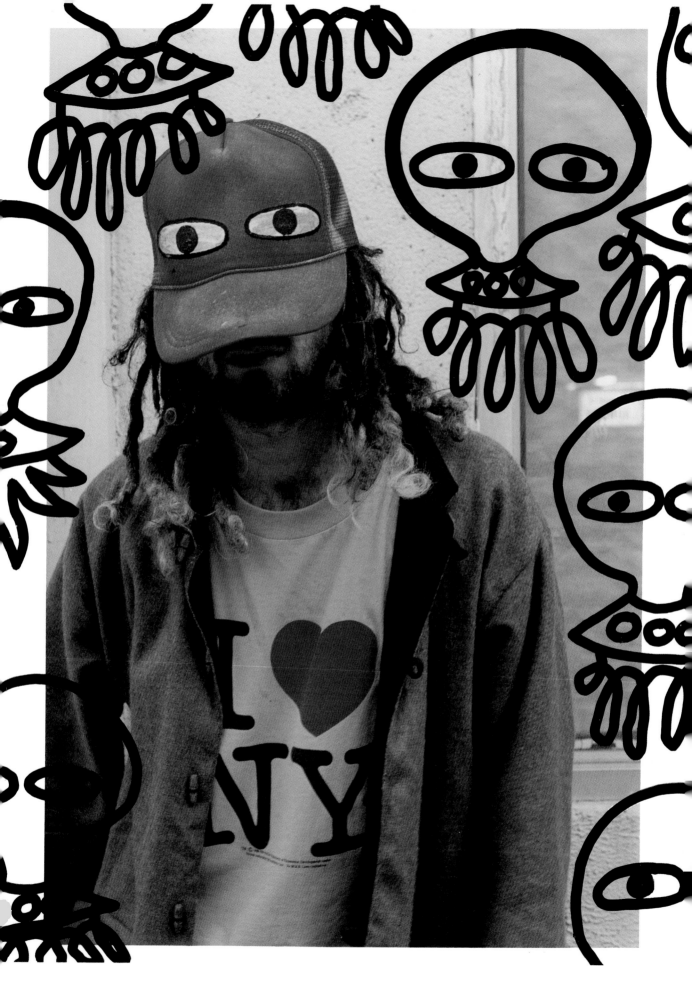

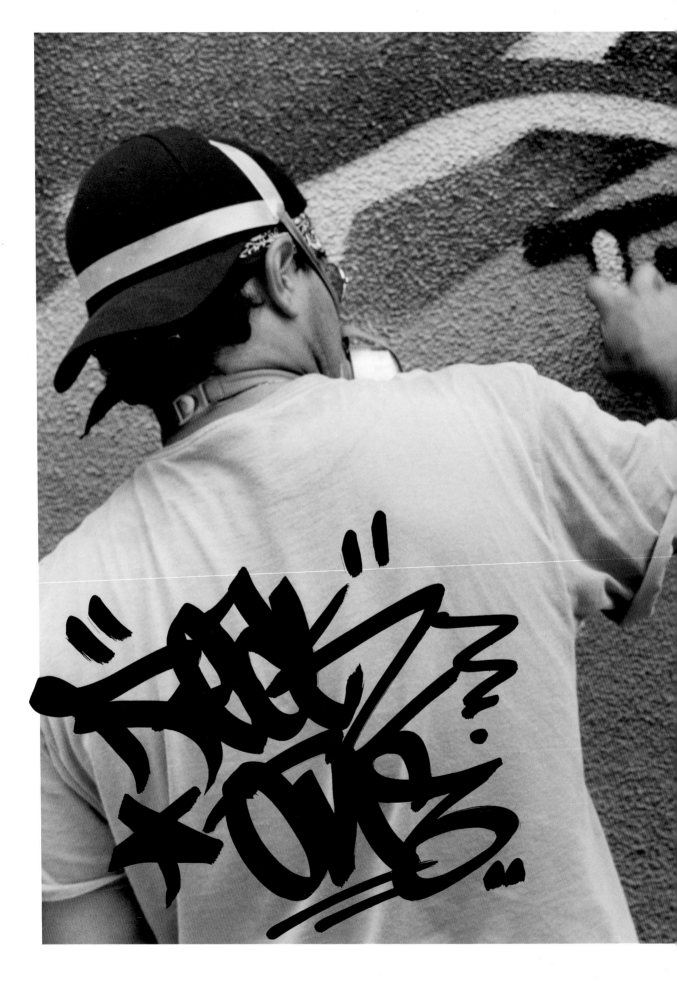

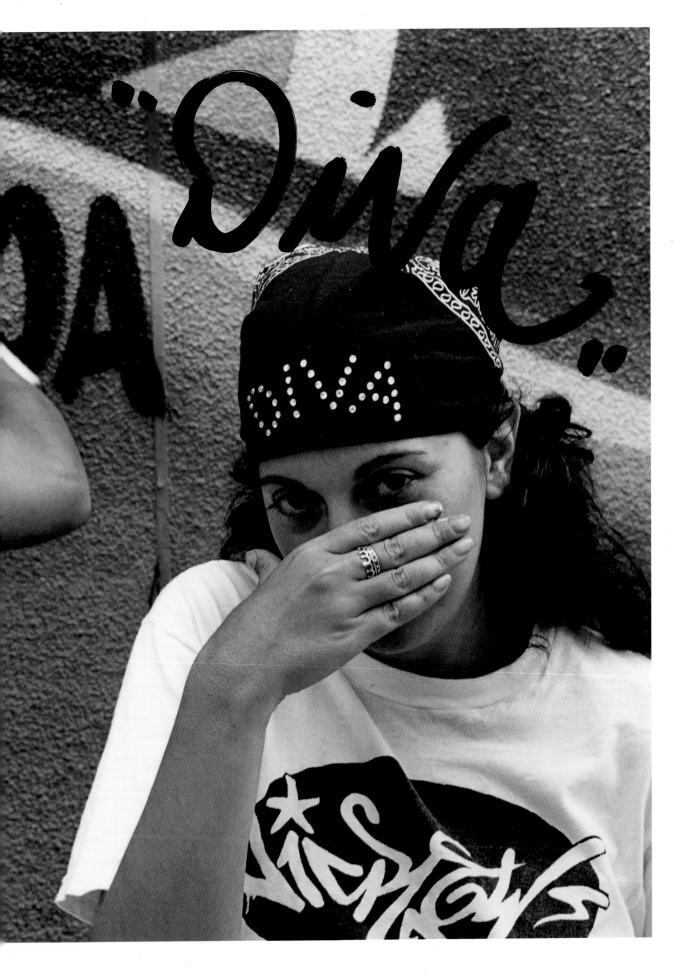

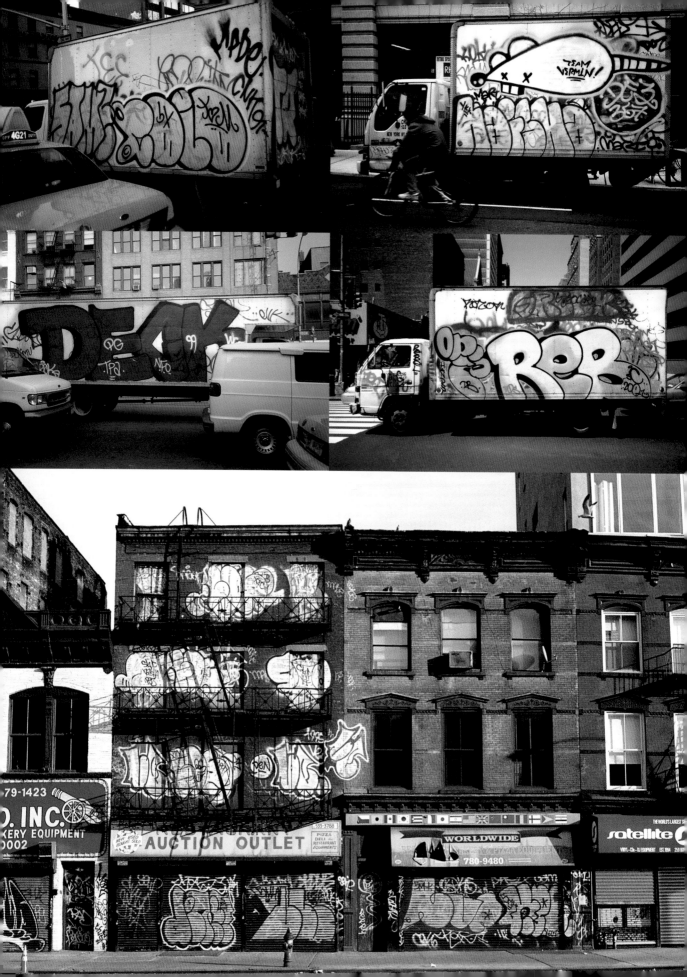

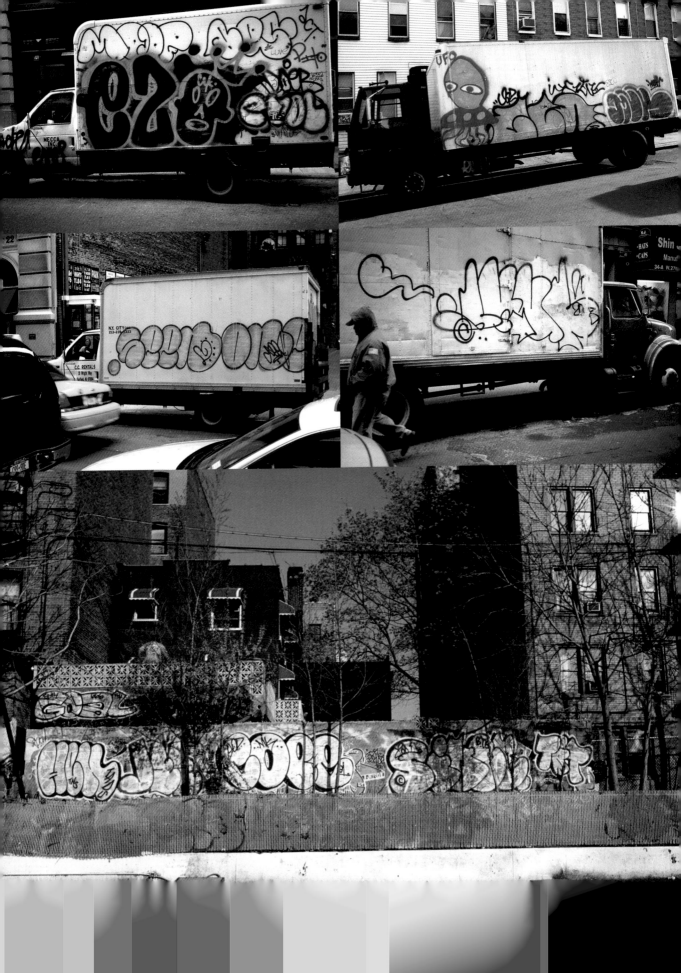

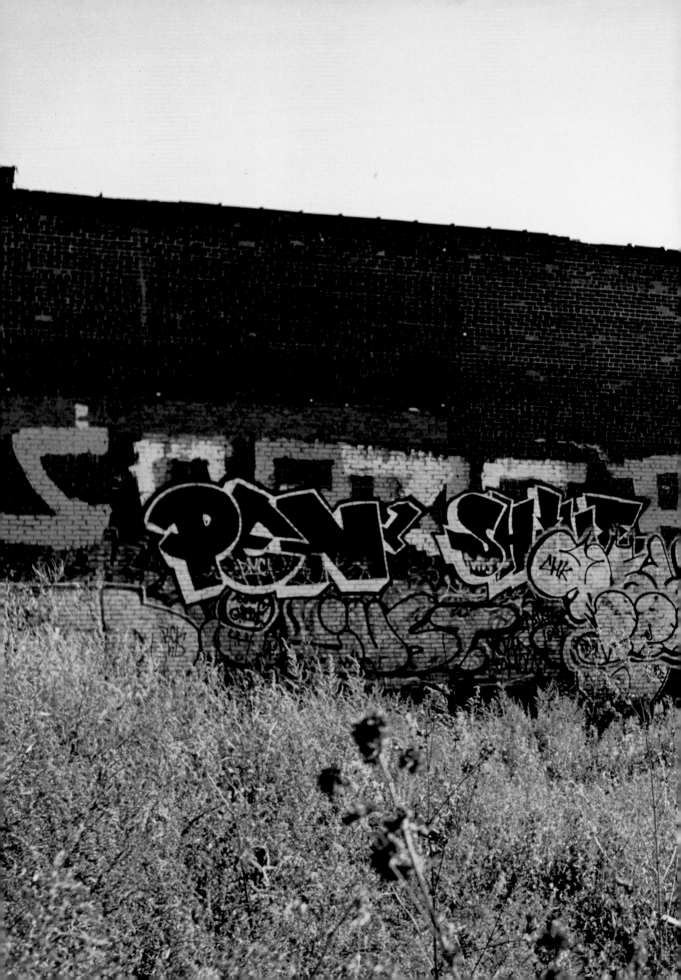

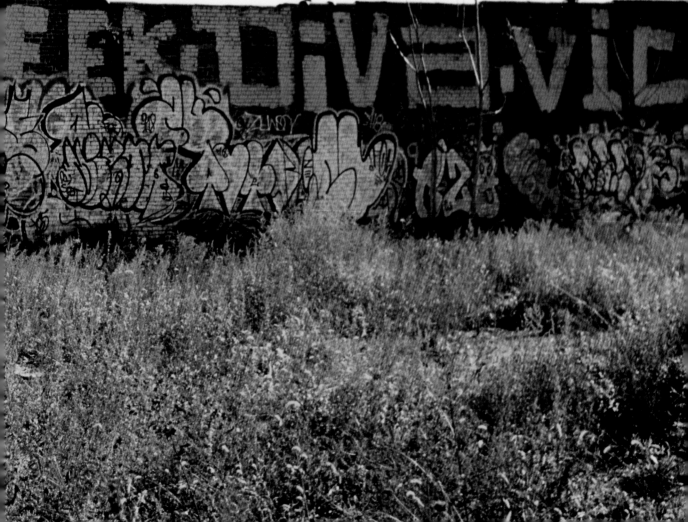

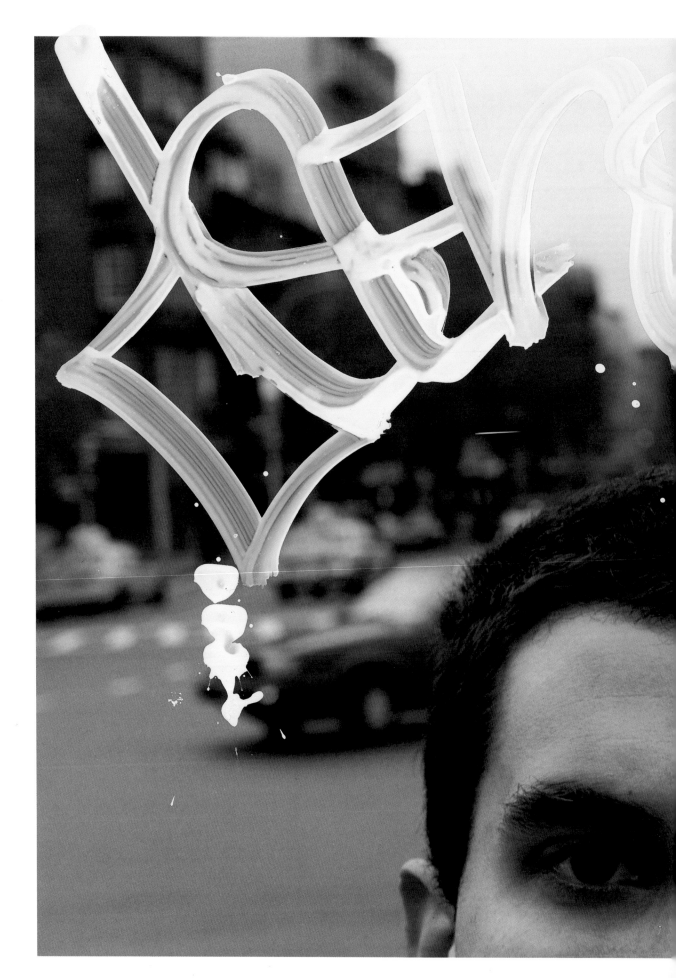

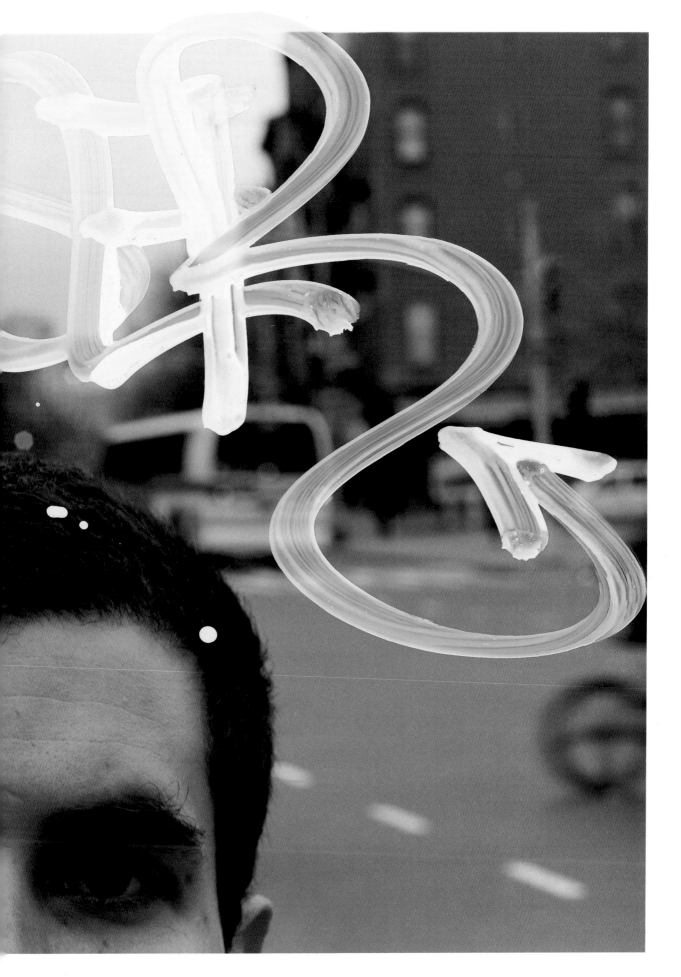

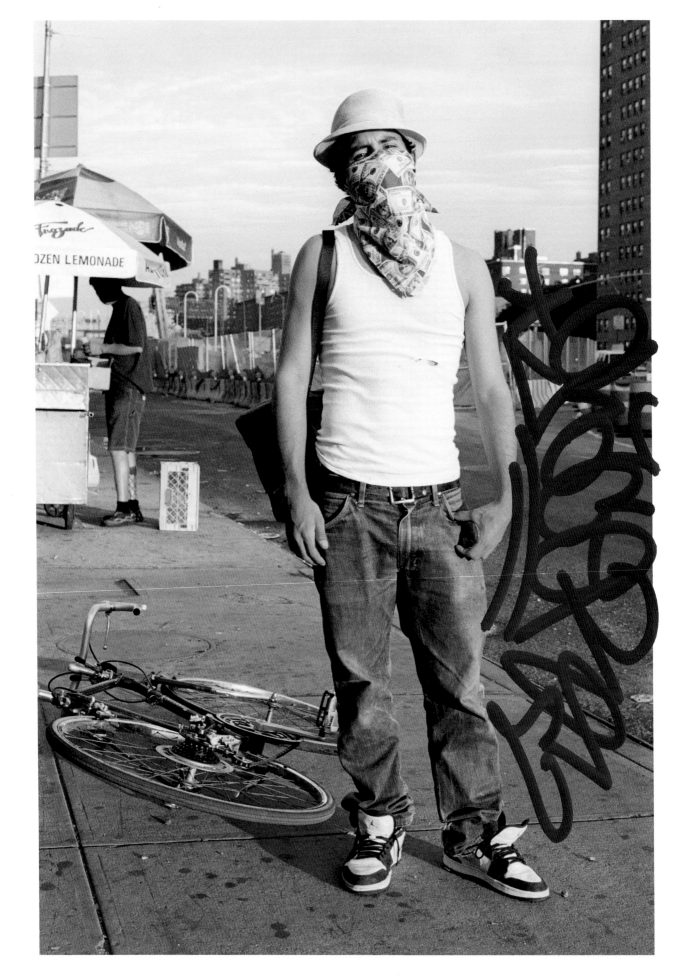

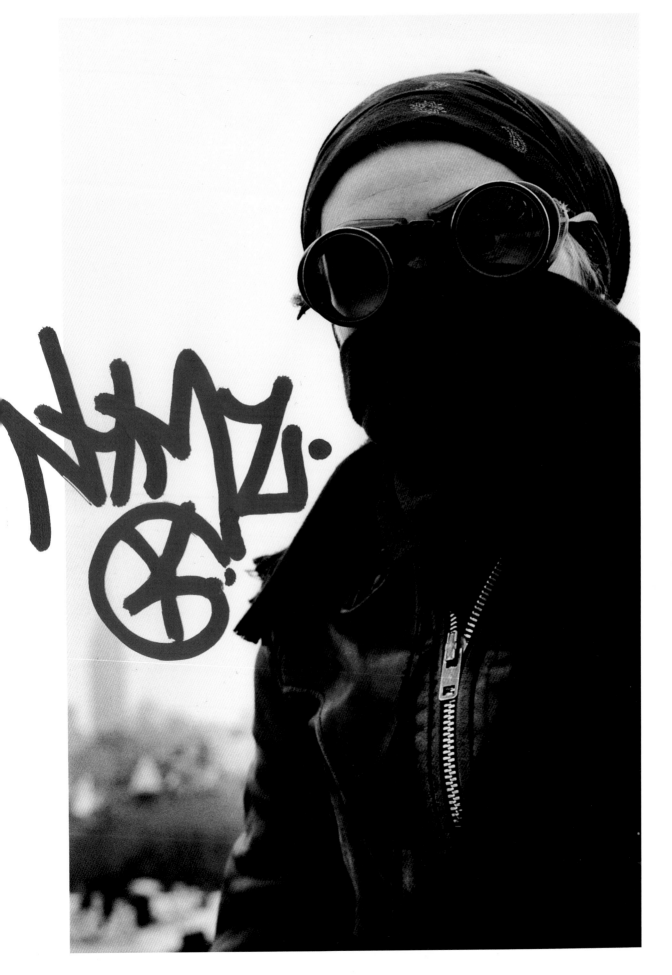

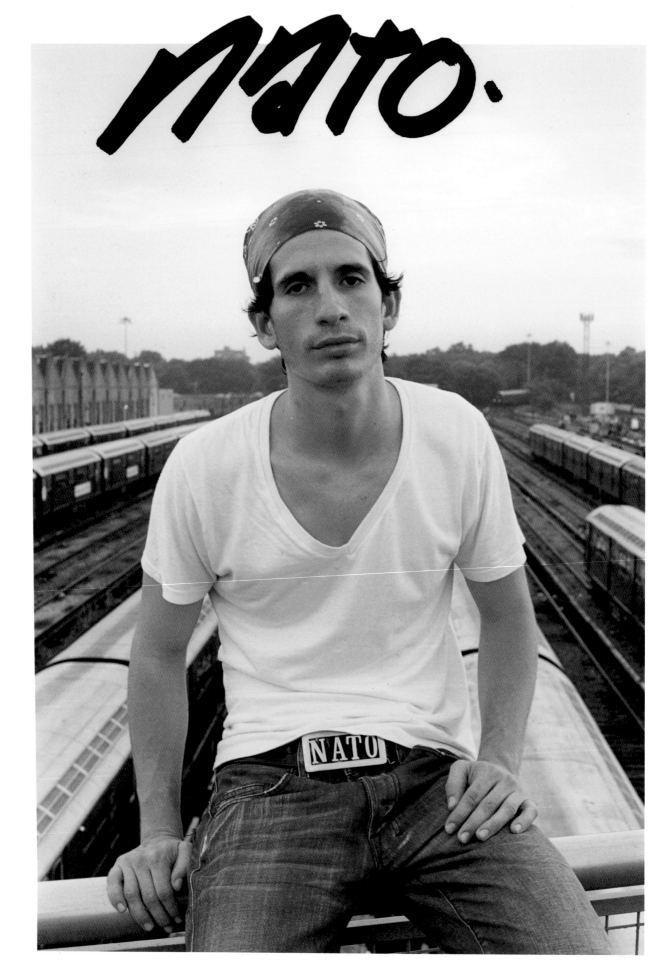

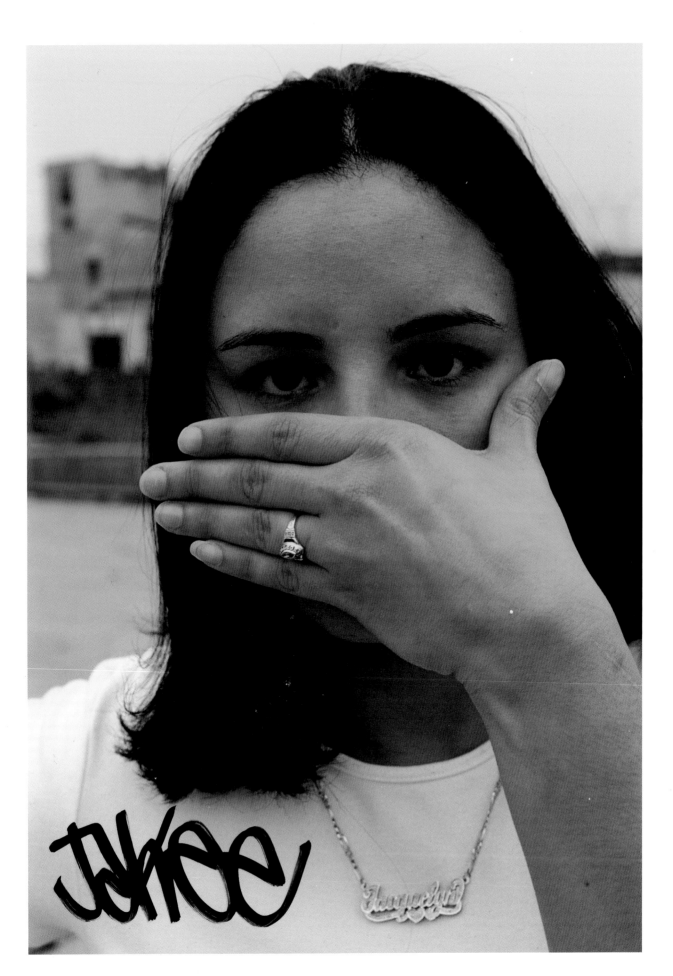

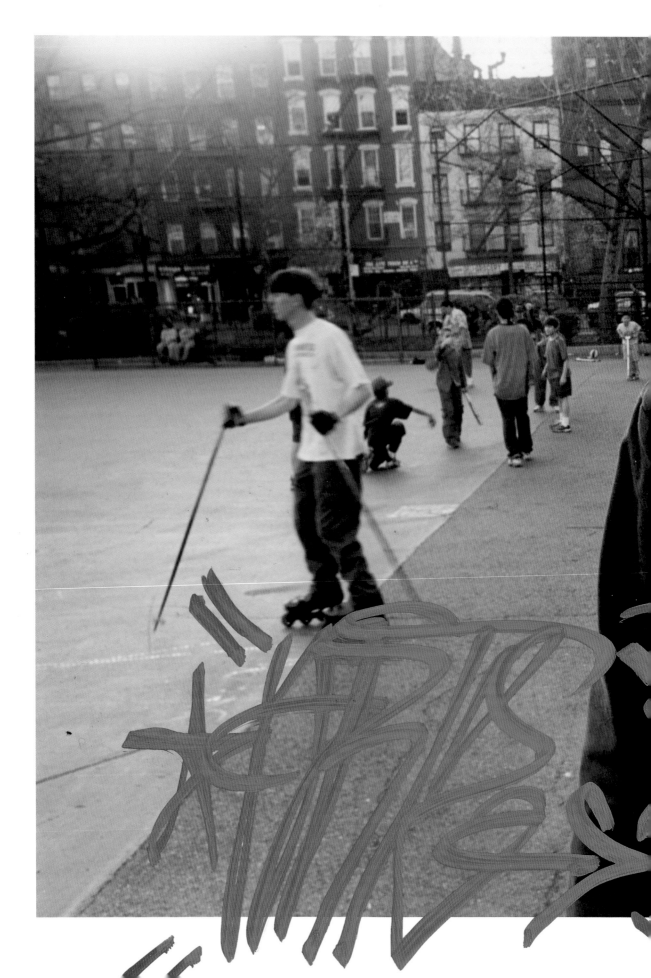

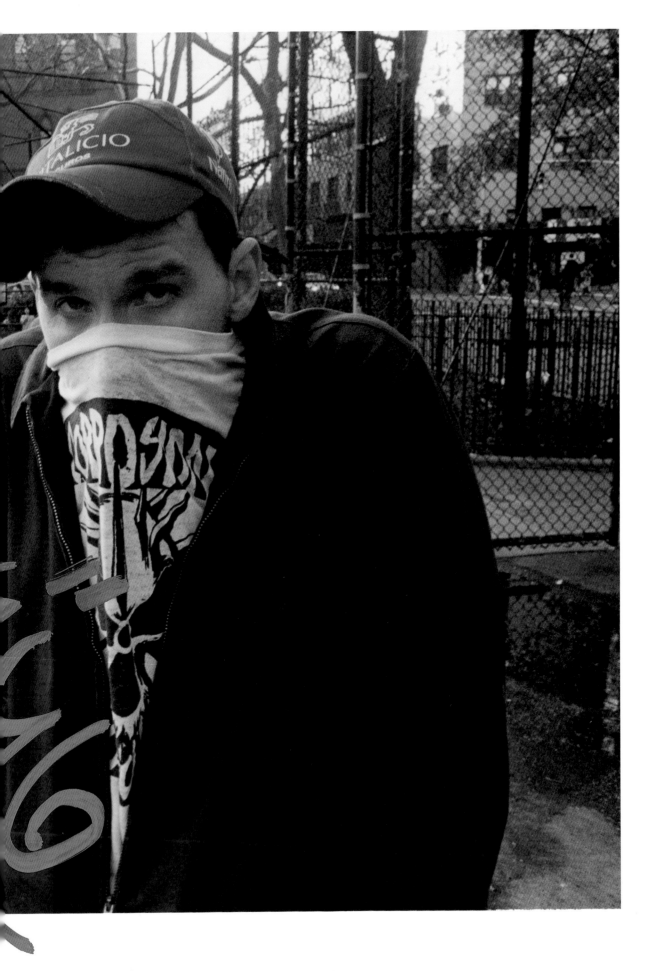

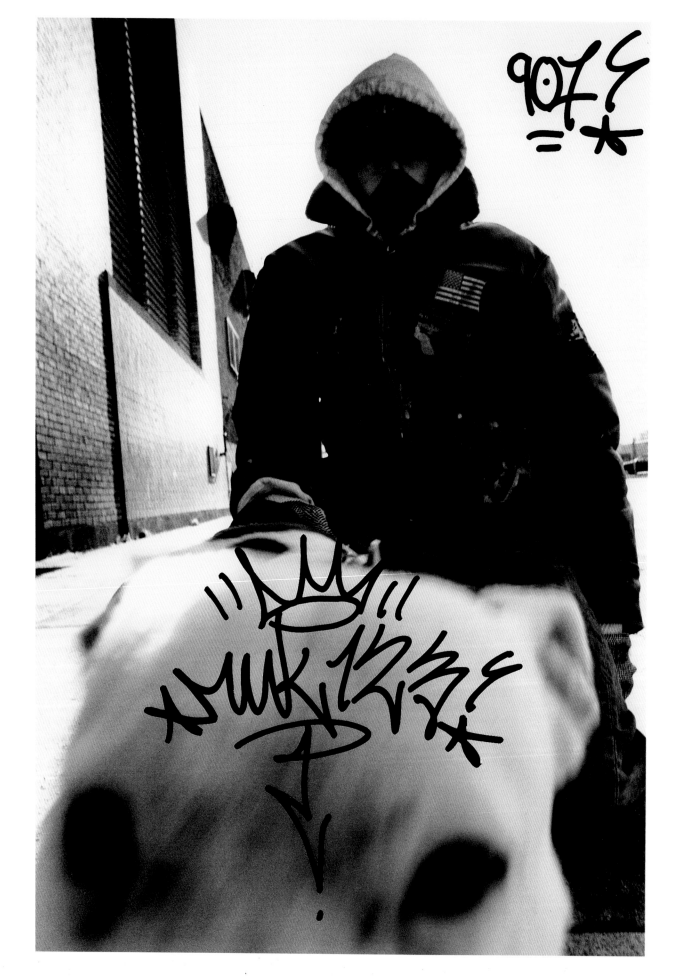

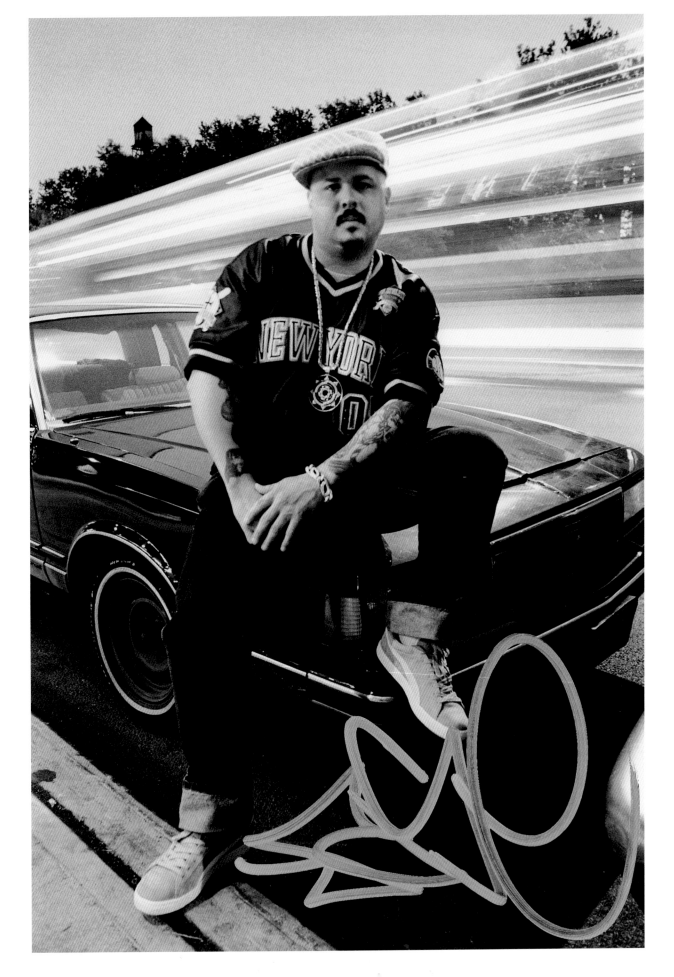

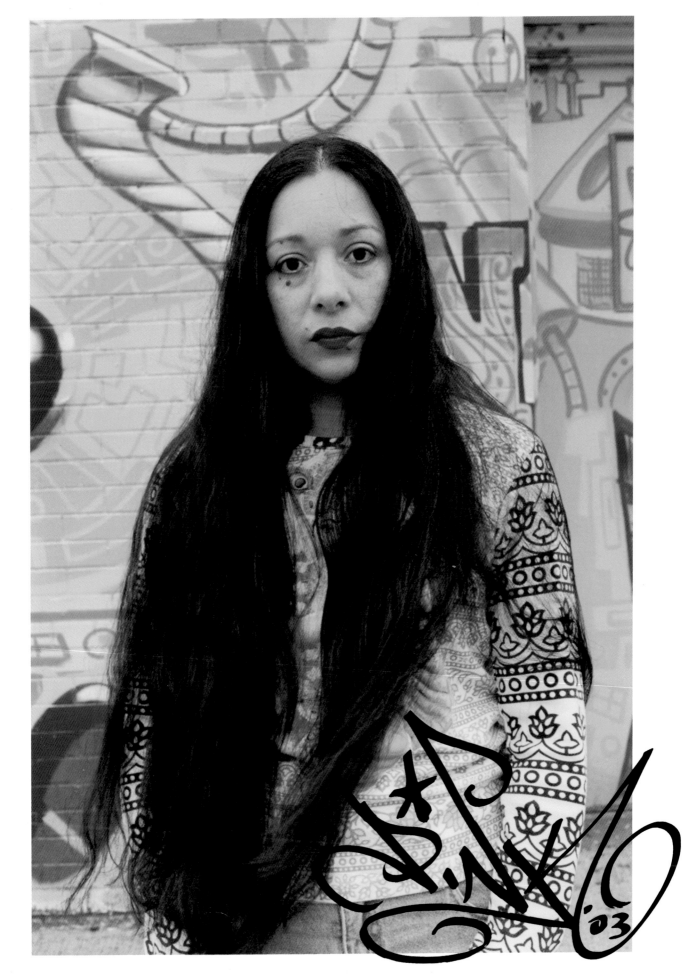

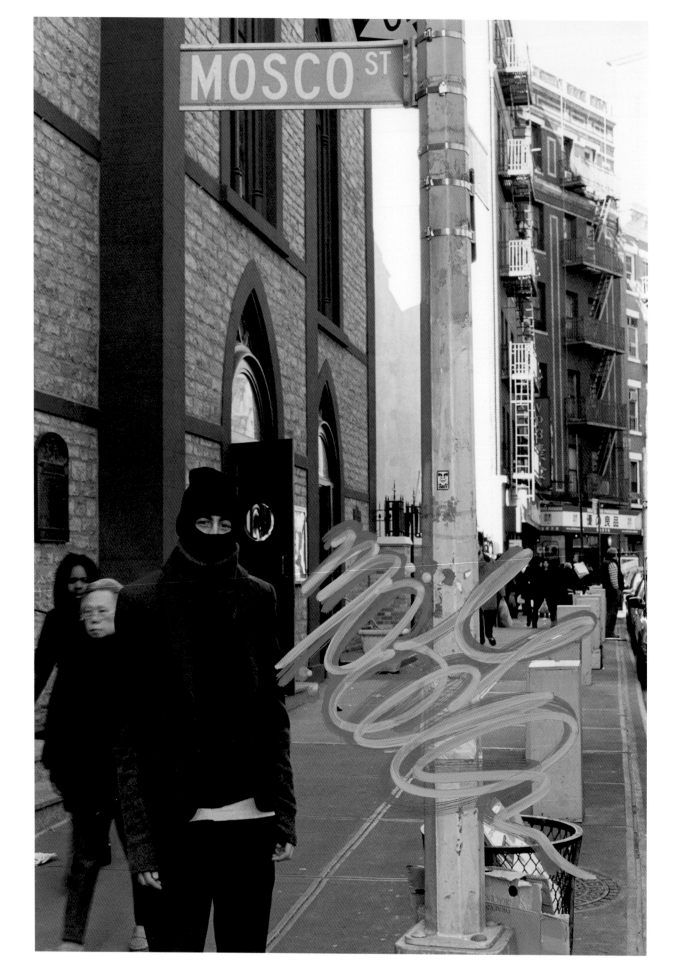

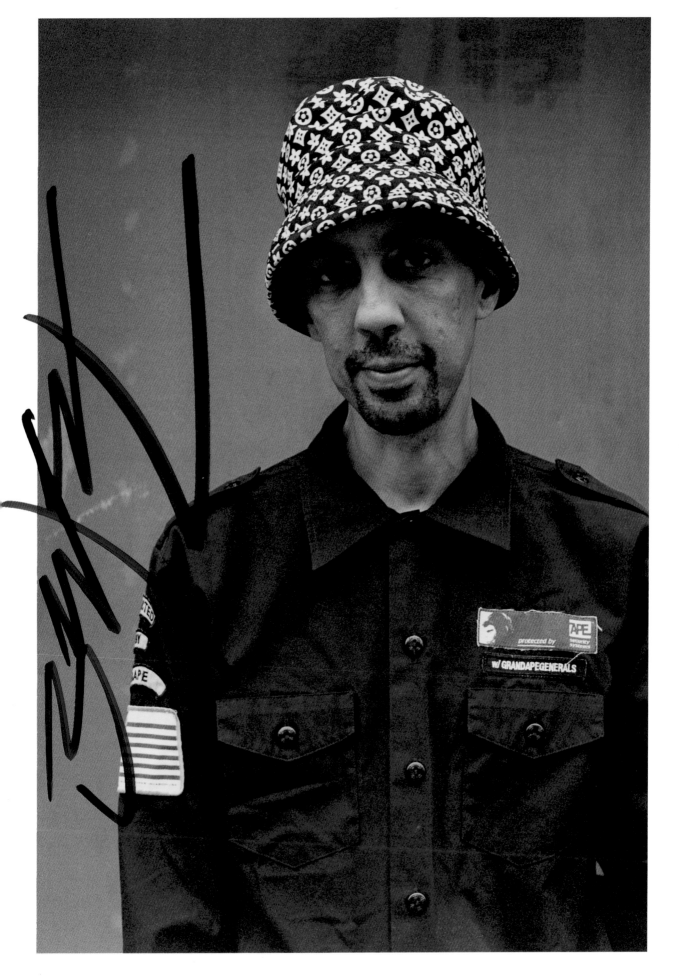

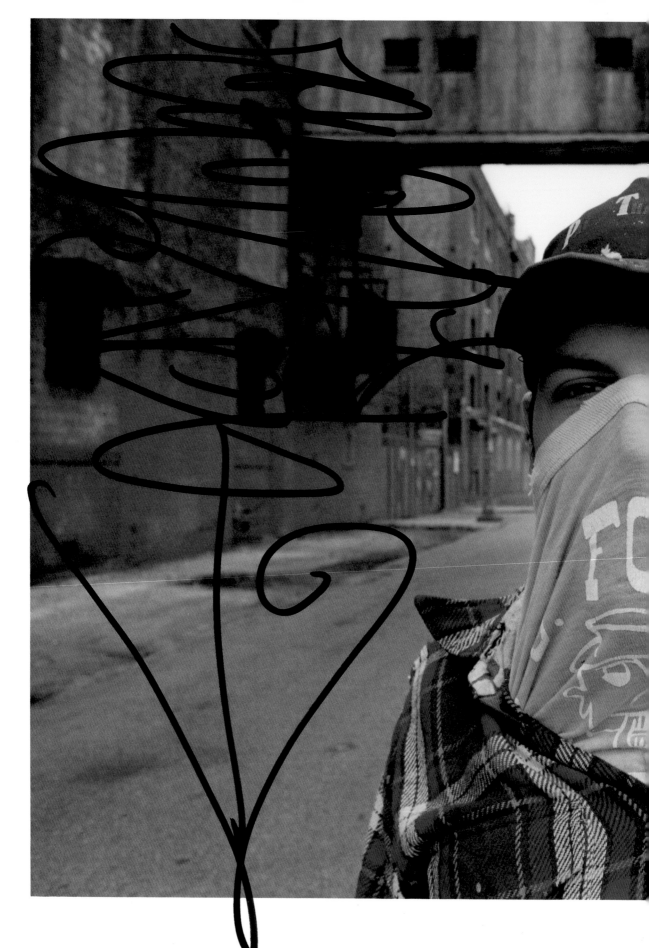

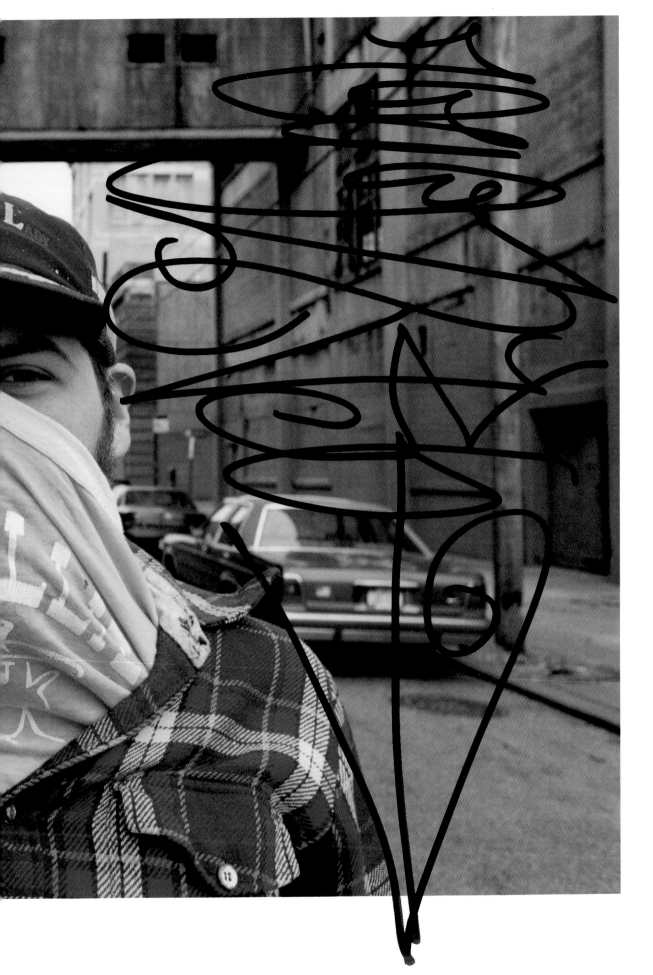

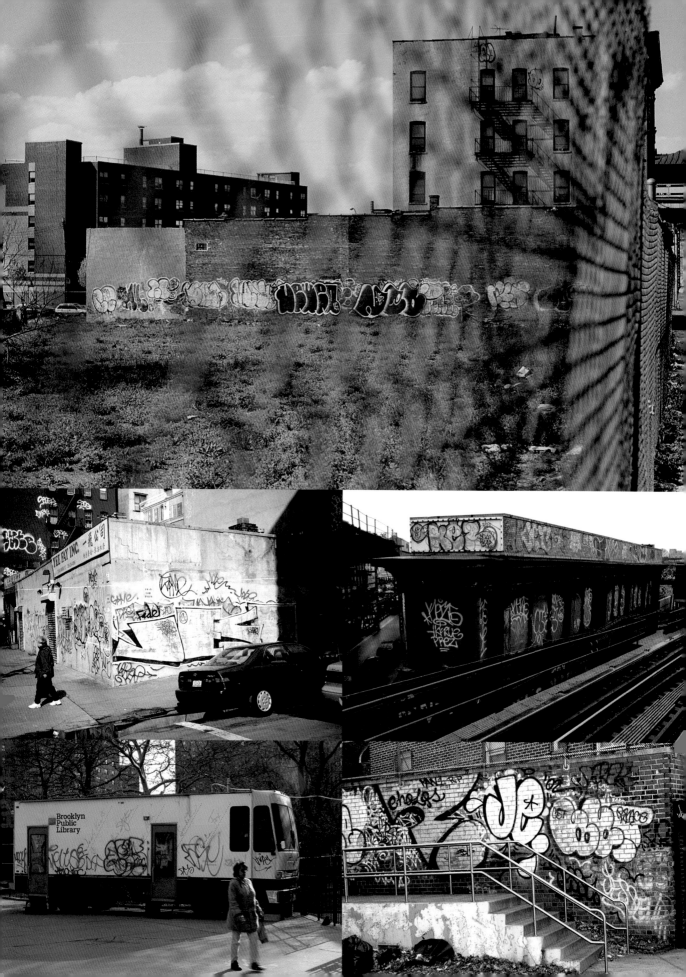

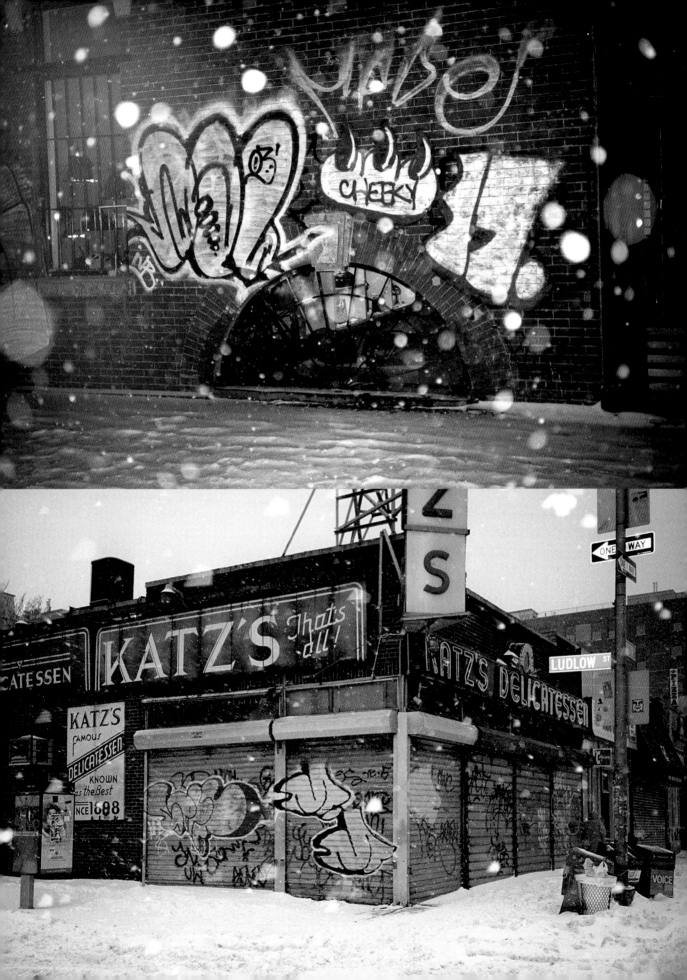

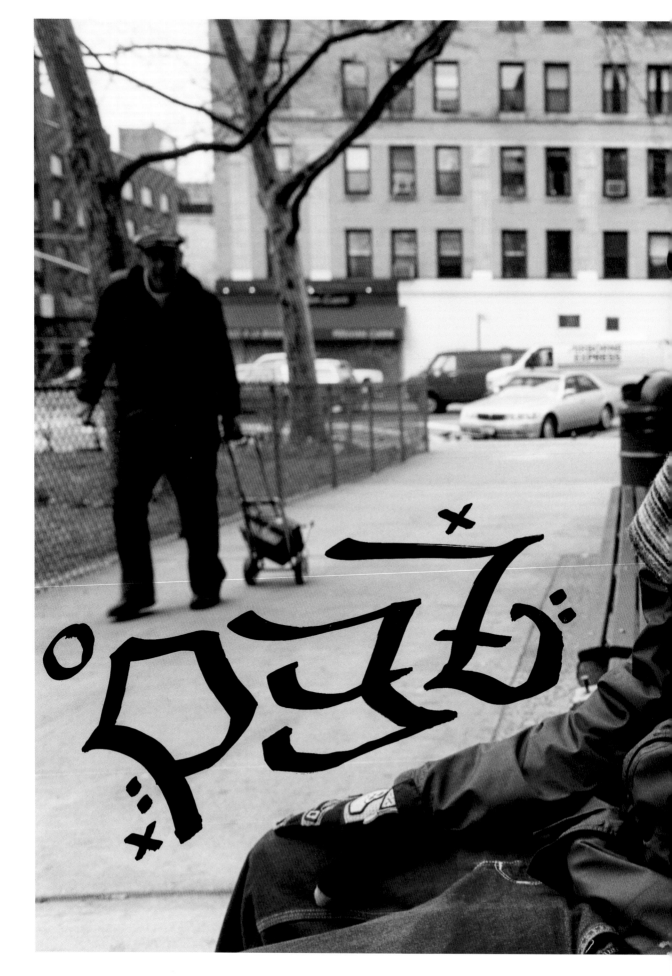

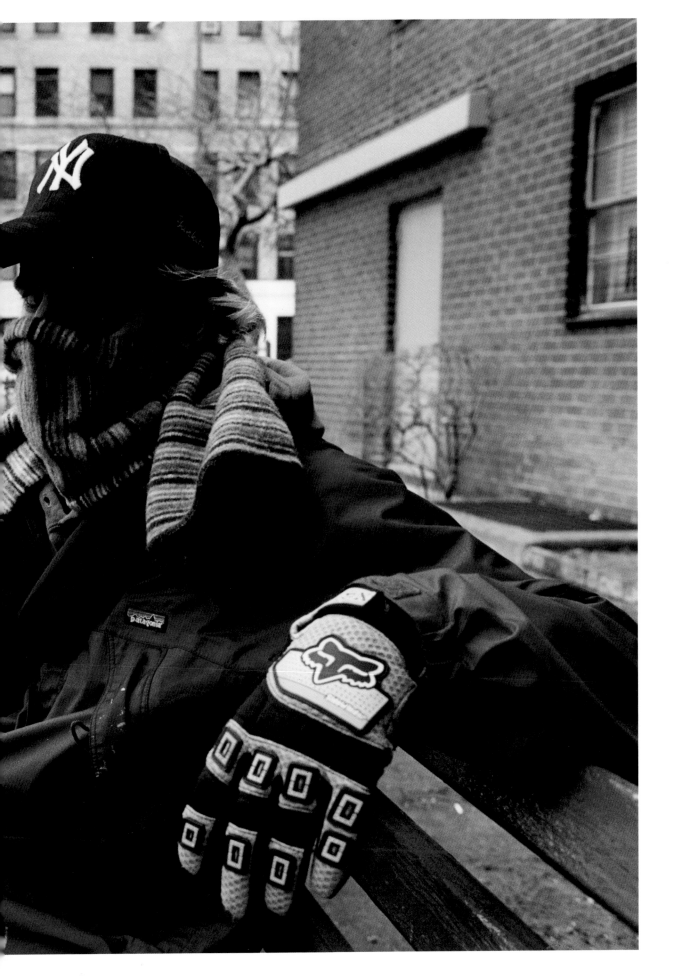

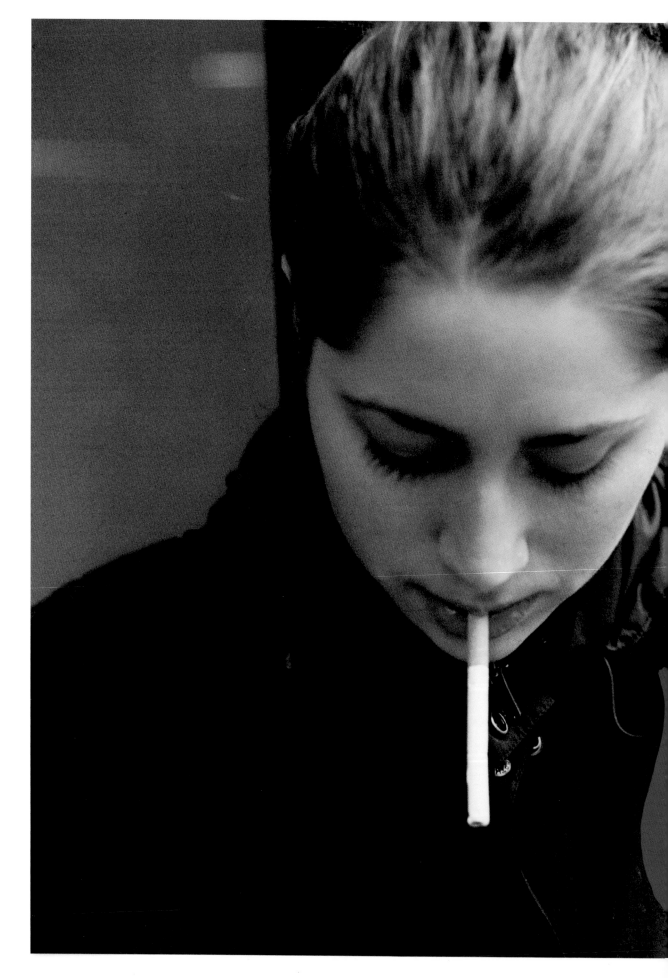

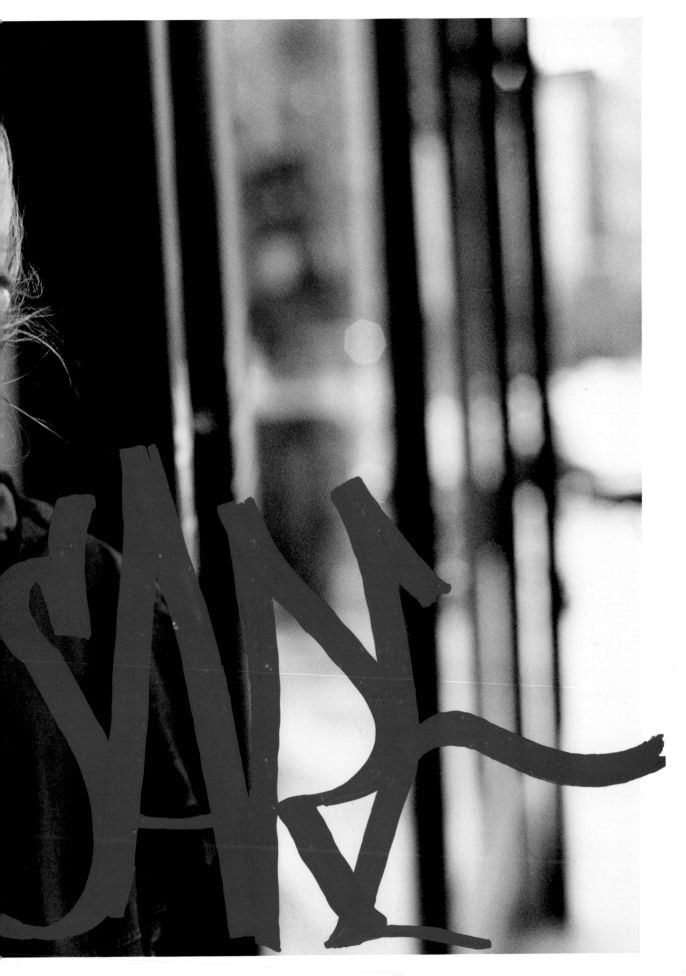

—THE DAYS ARE GONE OF THOSE early SUNDAY MORNIN MEETINGS AT THE CANDY STORE ON 79ST & 3AVE IN BAY RIDGE... WINTER, DRESSED IN A HOODED SWEATSHIRT & DUNGAREE JACKET WITH A BAG FULL OF PAINT, HOMEMADE BOMBERS, & REFILL INK CANS—"YO, WHO'S GOT THE TRAIN KEY??—THEN ITS OFF TO CHECK OUT THE 4AVE LAY-UPS—IT WAS 20° OUTSIDE BUT TOASTY IN THE TUNNELS!!

—IN HARD WINTER IT WOULD BE PACKED FROM 59ST TO PACIFIC ST & SOMETIMES "DOUBLE-TRACK!!—A LOT OF THE INSIDES ON THE BMTS CAME FROM THOSE LAY-UPS—LIGHTS WOULD BE OFF & IT WAS DARK & SCARY—YOU DIDN'T KNOW WHAT TO EXPECT BUT YOU'D BE READY FOR ANYTHING!—AND THEN THE SMELL...... AND THE SOUND OF THE TRAIN GOIN "BRRRRRRR.... CHEEEEE..... AS IT SAT---

—IT WAS A BLACK & WHITE EXPERIENCE!!!!!

—MAN, THINGS HAVE REALLY CHANGED—NOW ITS UP AT 4AM, PUT ON THE CAR PARTS & INSTEAD OF THE INK & PAINT, ITS SPUD WRENCHES!!! DAMN im JUST AS DIRTY AS i WAS BACK THEN EXCEPT NOW im A FULL FLEDGED WORKIN SLOB—

—SAME ROUTINE EVERY DAY.... WORK, EAT, SLEEP, WORK, EAT SLEEP UNTIL EVERY DAY IS THE SAME—EVEN THOUGH i love WORKIN THE IRON, IT IN NO WAY COMPARES TO THE THRILL OF GRAFFITI—BUT THATS THE CHOICE i MADE OR SHOULD i SAY WAS FORCED INTO—"YO, WHATCHU WRITE!!!!!

—SOME PEOPLE DECIDED TO USE THEIR TALENTS (IF YOU CAN CALL IT THAT) TO MAKE MONEY & AVOID MY DILEMMA— GRAFFITI FOR MONEY—i UNDERSTAND "YOU GOTTA DO WHAT YOU GOTTA DO" BUT i really GET A KICK OUT OF HOW SOME PEOPLE WENT FROM BEIN STREET-KIDS TO "ART-TEETS" IN THE PROCESS & HOW CONCERNED THEY ARE TO BE RECOGNIZED OR LEGITIMATE!!—i GUESS im THE RED HEADED BASTARD STEP-CHILD!!!!!!!!

— EVERYBODIES GOT AN "ANGLE" + THERES MORE WHORES IN THE GAME NOW THEN THERE USED TO BE ON THE ~~DEUCE~~ — I LIKED IT BETTER IN THE "OLD" DAYS WHEN YOU HAD TO FIGHT EVERY STEP OF THE WAY TO GET YOURS OR SHOULD I SAY JUST TO KEEP YOUR SHIT! NOW ITS A BIG NETWORKING SOCIAL EVENT WHERE EVERYBODY MAKES CONTACTS + JERKS EACH OTHER OFF — WAY TOO MANY JACK-ASSES!!!!
— IN ~~200~~ 2003 ITS ALL ABOUT GETTIN PAID FOR DOIN AS LITTLE AS POSSIBLE OR SELLIN YOURSELF AS "A CHEAP PRODUCT" BUT THEN AGAIN THEY FORCED US INTO THIS...... JUST REMEMBER "YOU ARE JUST A PRODUCT!! — THATS WHY I AVOID MOST PROJECTS, PEOPLE + SHOWS + IF I MAY QUOTE "MR ANTISOCIAL" HIMSELF.... "FUCK EVERYBODY!!!
— WHEN I FIRST HEARD ABOUT THIS BOOK, I WAS SUSPECT.— AFTER ALL WHO IS THIS GUY + WHY DOES HE WANNA PHOTOGRAFF "OUTLAW WRITERS" MAYBE THATS WHY IT TOOK ME ABOUT A YEAR TO GET BACK TO HIM — I JUST WASNT SURE + IM STILL SKEPTICAL BUT LETS HOPE FOR THE BEST — AS I QUIZZED "PETE" I FOUND OUT HE WASNT FROM N.Y. (BUT THAT SHOULDNT BE NO BIG SURPRISE NOWADAYS) + HE WASNT TOO UP ON THINGS.... BUT THAT DOESNT NECESSARILY HAVE TO BE A BAD THING — AFTER ALL LOOK AT "HENRY" WHEN HE FIRST STARTED — HE DIDNT KNOW MUCH BUT HIS MOTIVES WERE PURE + YOU CAN THANK HIM FOR GIVIN KIDS THAT HAD NOTHIN + NO POWER, A VOICE!!! AND UNFORTUNATELY, YOUR VOICE IS THE ONLY THING YOU GOT — THEYLL BREAK YOU ANY WAY THEY CAN WHETHER BY THEIR RULES OR THEIR LAWS — YOU GOT A VOICE,... SO USE IT...... WISELY.!!!
— TO ME, IT ALL COMES DOWN TO "MOTIVES" — IF YOUR MOTIVES ARE FAULTY IT'LL SHOW + IF YOUR MOTIVES ARE TRUE THEN THAT'LL SHOW TOO — UNFORTUNATELY, THEY MAKE US PLAY THE "WHORE" FORCE YOU INTO A SCENARIO YOU DON'T WANNA BE IN + IN TURN WE COME UP WITH

OUR ~~FORM~~ FORM OF "GRAFFITI" — WHICH IS JUST A
REACTION TO OUR SCENARIO — WHAT YOU GOTTA remember is
SINCE WERE ALL PLAYERS IN THIS GAME & PEOPLE ARE
PITTED AGAINST EACH OTHER FOR NON-EXISTENT reasons
SUCH AS RACE, RELIGION OR LIFESTYLE — THERE'S A 3RD
GUY STANDIN THERE BEHIND A CURTAIN CONTROLLING IT ALL —
AS "DANKO THE IRONWORKER" USTA TO SAY "OPEN YOU HEART,
PREPARE YOU ASS"!!!

— GRAFFITI ART MAYBE OVER 30 YRS OLD BUT GRAFFITI
ARTISTS ARE STILL IN THEIR FORMING STAGES... WITH AGE COMES
WISDOM EXCEPT IN MY CASE AS MY OLD MAN USE TO TELL ME...
"YOUR GROWIN OLDER BUT NOT ANY WISER" AND UNLIKE
ROCK-N-ROLL WE CAN STILL BE DANGEROUS... AS A PEOPLE
I'LL BE THE FIRST TO ADMIT, WE'RE VERY STUPID BUT WHEN
YOU BREAK IT DOWN & SEE HOW IT WAS CREATED BY KIDS
OUT OF VIRTUALLY NOTHING WELL THAT TAKES SOME SMARTS —
— NOW I DON'T KNOW IF IM A WRITER, WRITER (ILL SAVE THAT
FOR "CORE") CAUSE I AINT CLAIM ANYTHING — IM NOT INTO
CREWS & I GENERALLY DONT LIKE WRITERS AS PEOPLE, BUT
I WILL SAY I LOVE WHAT WE DO... WHEN ME & "COST" WERE
BOMBIN, WE COULD'VE TOOK A CREW ~~OF~~ OF 10 OR 20 GUYS OUT
CAUSE THATS HOW GOOD OUR GAME WAS. — SO WHY DO YOU
NEED PEOPLE?? LEARN ABOUT THE "ZERO THEORY"
TO ENLIGHTEN YOURSELF... ID RATHER SEE SOMEONES TOYEST
SHIT ON A WALL, THEN THEIR BEST SHIT ON CANVAS!

— TO ME GRAFFITI IS AN "OUTSIDE ART" CREATED BY TRUE
OUTSIDERS — ILL NEVER FIX MY SHIT — ID RATHER SEE IT
WEATHER, FADE OR BE ALTERED BY SOMEONE WITH INDEPENDANT
THOUGHTS — THATS GRAFFITI TO ME!!! ITS A "HOME GROWN"
(COURTESY OF BT. NYC) OPERATION — IF MY SHIT SUCKS, ITS ALL ME
& IF MY SHITS HALF DECENT WELL THEN I GOT LUCKY THAT DAY!!!

— SO I THOUGHT THE CONCEPT OF THIS BOOK MIGHT BE OK BUT YOU NEVER KNOW UNTIL IT COMES OUT — IT MIGHT SUCK! BUT I SAW HIS PHOTOS BEFORE HAND & THERE REAL GOOD — NOW IT ALL DEPENDS ON HOW ITS PRODUCED — I HOPE THE PHOTOS STAY 11×14 CAUSE ANYTHING SMALLER IS HALF STEPPIN & POSSIBLY TOY!! — TRUE, WHO WANTS TO SEE WRITERS FACES EXCEPT THE COPS... CAUSE IT CAN ONLY HELP THEM OUT & BELIEVE ME THEY DONT NEED ANY MORE HELP THEN WHAT YOU "JACK-ASSES" ARE GIVIN THEY — LET THEM WORK FOR THEIR MONEY LIKE I WORK FOR MINE! THE HARD WAY!! — BUT AT THE SAME TIME I WANNA SEE US ELEVATE OURSELVES CAUSE IF YOU THINK ABOUT IT IF YOU'VE REALLY COMMITTED A CRIME, A REAL CRIME, YOU WOULDNT TAKE A PHOTOGRAFF OF IT CAUSE ITS NOT SOMETHIN YOUR PROUD OF — BUT WE PHOTOGRAFF ALL OUR STUF CAUSE WERE PROUD OF IT SO HOW COULD SOMETHIN YOUR PROUD OF "BE A CRIME?? — IT MAY SOUND SKEWED BUT THATS THE WAY I SEE IT! — HARDCORE GRAFFITI CAN BE A SELF DESTRUCTIVE LIFESTYLE BUT THE WAY I LOOK AT IT, WE ALL HAVE THE GOD GIVIN RIGHT TO DESTROY OURSELVES!! — NOT ME ON YOU, BUT ME ON ME! — GOOD OR BAD, ITS GOT TO BE RECONIZED!!!

— SO MANY PEOPLE HAVE PAVED THE WAY BEFORE US, FROM THE TOYS TO THE LEGENDS — SOMETHING HAS BEEN MADE OUT OF NOTHING — AND ITS STILL EVOLVING & IN MY OPINION ITS GOT A LONG WAY TO GO BEFORE IT GETS MAXED OUT! — ITS A LONG DISTANCE RACE — YOU JUST GOTTA DO YOUR TIME — 10, 20, 30, 40, 50, 60 YRS WITH PASSION & BELIEF & YOULL GET YOURS — HOW CAN YOU DENY SOME ONE WHOSE DEDICATED THEIR WHOLE LIFE TO SOMETHIN? WHETHER ITS CARPENTRY, SKATEBOARDIN, MUSIC, RACIN, OR WRITIN FOR THAT MATTER — JUST DO SOMETHIN, ANYTHING, BUT DO IT WITH BELIEF & FOR THE RIGHT REASONS & YOU WILL NOT BE DENIED!

— THE TRUTH ALWAYS HAS A WAY OF COMIN OUT & IF YOU DO THINGS FOR THE RIGHT REASONS IT WILL COME OUT —

THE MAIN AVENUE WE STILL NEED TO RUN DOWN IS OURSELVES — GETTIN TO THE CORE OF THE MATTER BEHIND ALL THE COLORS — WHO WE REALLY ARE AS INDIVIDUALS — ITS NOT REALLY ABOUT TRYIN TO USE PEANUT SHELLS, PANTY-HOSE & GUM WRAPPERS TO MAKE ORIGINAL GRAFFITI — IF ITS IN YOU, THEN ITS IN YOU !! — TRUE WILD STYLE COMES FROM WITHIN !! A FEW PEOPLE HAVE SAID TO ME OVER THE YEARS "BUT YOU DID IT WITH SO MANY DIFFERENT THINGS: WHEATPASTIN, ROLLERS, ~~CANVAS~~ BOLTED UP CANVAS PIECIN "YOU KEEP REINVENTING YOURSELF" BUT I DONT LOOK AT IT LIKE THAT — WHEN I WAS 18 I DID THE ~~XXXX~~ CHECKERBOARD PIECE — I USED A PILOT, BUCKET PAINT & MASKING TAPE — ITS IN MY NATURE & MORE THAN THAT... IM FUCKED UP!! AND ILL USE WHATEVER I FEEL LIKE, WHENEVER I FEEL LIKE — IM NOT TRYIN TO REINVENT MYSELF! THIS IS JUST HOW I AM — IM NOT INTO RULES OR GRAFFITI TRENDS & CHANCES ARE IF YOUR DOIN SOMETHIN, THEN IM GONNA DO THE EXACT OPPOSITE CAUSE IM NOT LOOKIN TO BECOME SOMEBODY OR CLIMB THE GRAFFITI WHORE LADDER!! "ESPO" SAID IT RIGHT WHEN HE SAID "EVERYONES GETTIN THEMSELVES A GIMMICK" & NOW THEY'RE RUNNIN WITH IT THINKIN THEY'RE "PICASSO" BUT REALLY ITS NOTHIN SPECIAL — JUST DIME A DOZEN SHIT WITH A LABEL OF 1 OF 100 MADE — SO THAT YOU'LL BUY IT THINKIN YOUR GETTIN A COLLECTORS ITEM — "THE GREAT ROCK-N-ROLL SWINDLE RETASHED!!

— ITS GOOD TO SEE A KID LIKE "NOU" TRYIN TO DO SOMETHIN AT LEAST HES TRYIN TO GET TO THE CORE — ILL GIVE HIM AN "A" FOR EFFORT — INSTEAD OF "YO, CHECK THE STYLE, YO! " I USED A 1972 RING AROUND MY DICK YELLOW" & "BLUE BALLS 1965 TESTORS CAN"! SAVE IT FOR SOMEBODY WHO GIVES A SHIT......

— Which brings me BACK TO THE TRUTH... whatever that may be — the great thing about the world we live in is that it takes ALL KINDS... THE TOYS, THE BOMBERS, THE BURNERS, THE OUTLAWS, THE LEGAL EAGLES, THE CHEESEBALLS & THE HARDCORE (OK we could use a lot less cheeseballs!!) But as "NUKE" says "it's needed"—

— The people in THIS BOOK are all individuals 1st but all share a common thread — Some people i know personally or know of their work & respect it and some i dont know & never wanna know! & Like i say it all comes down TO MOTIVES — AND unfortunately There's a lot of guys in our profession with FAULTY motives — & if your confused then listen to "SKEME"—

— what you have to realize ~~too~~ is we're ACTUALLY MEN even though most of us still act like kids, the unfortunate TRUTH is we are grown men (believe me, i still cant believe it!!) So put some effort into your SHIT & forget about the "Take the money & Run, Graffiti For Dollars philosophy" — RUN AN operation where you HIT em & HIT em HARD — We need to Be paintin 5, 10, 20 story Buildings top to Bottom with somethin to say — Doin shit thats gonna last the test of time — where NONE OF These people in power, (THE ART CRITICS, HISTORIANS OR POLITICIANS) CAN DISCOUNT YOUR EXISTENCE — ~~Publish~~ ~~a Book~~ write a Book, publish it yourself... Work 3 jobs if you have to! Get the tools so you can paint a 10 story Building!! Just put effort into what you do cause your NAME is the ONLY thing you GOT — And Remember... theres a story Behind every Face IN THIS WORLD AND IN THAT STORY ARE, TRUTH & lies.

— lets just Get to The TRUTH!! ✕ IN MEMORY OF MY BEST FRIEND... JOE YOUNG
2/26/93 — 5/20/03

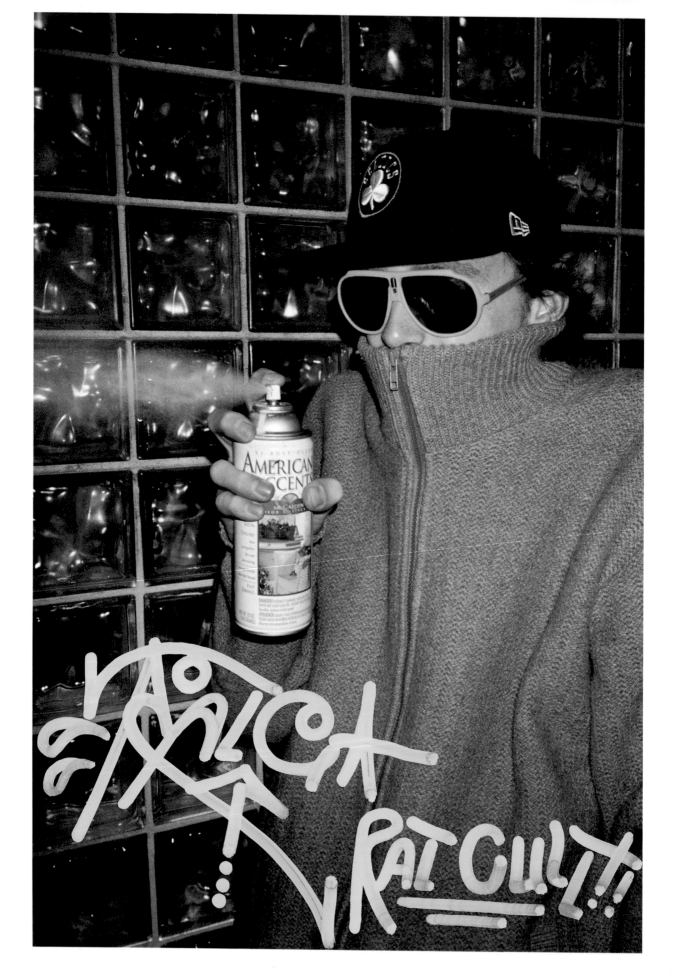

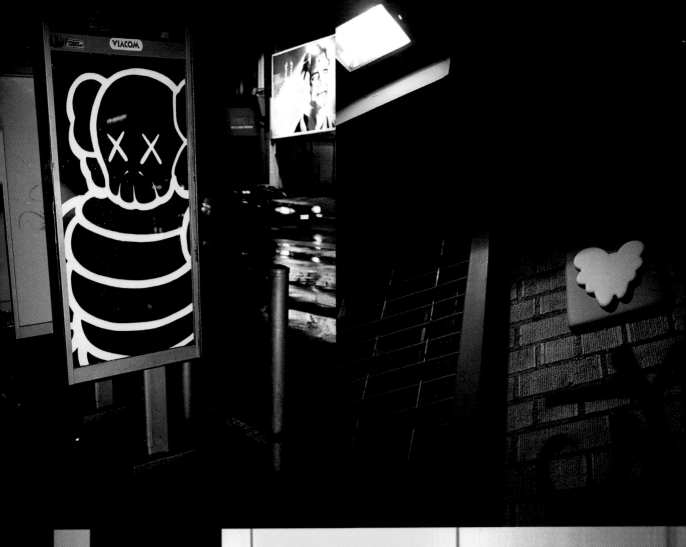

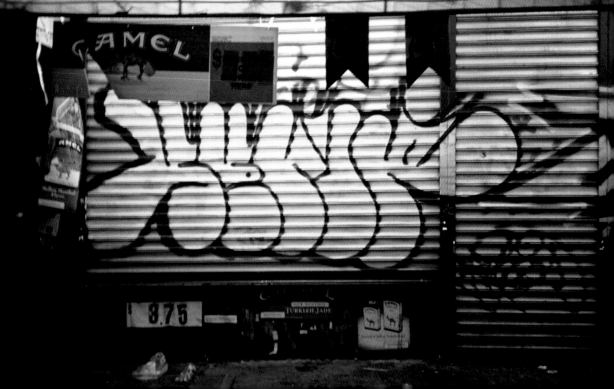

LOTTO - COLD BEER & SODA

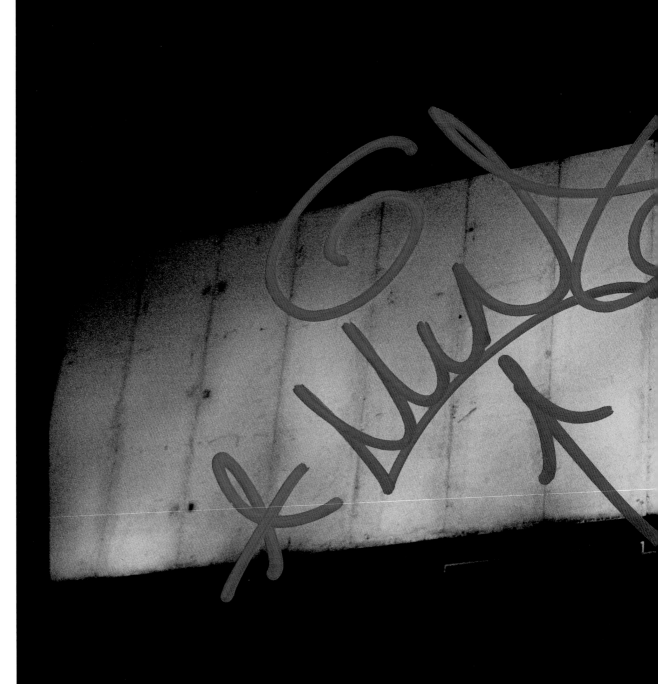

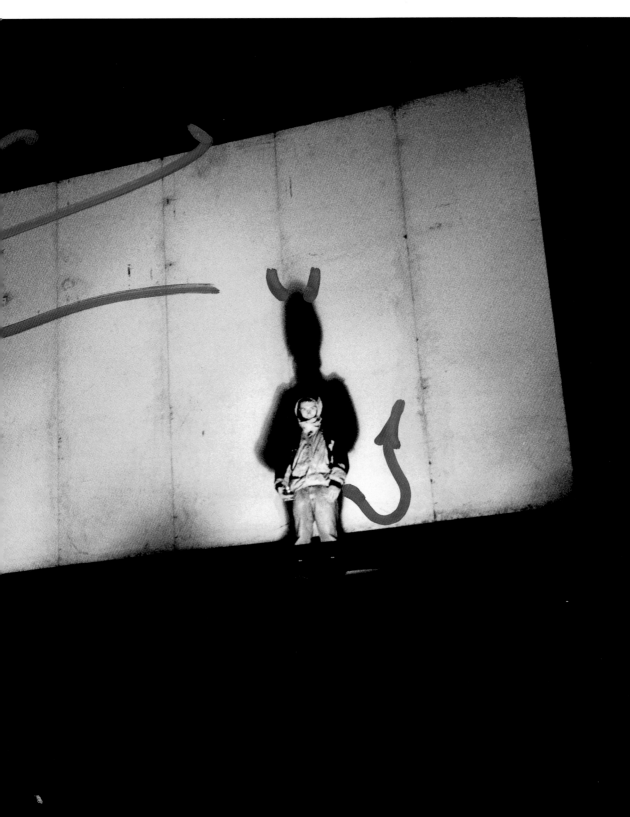

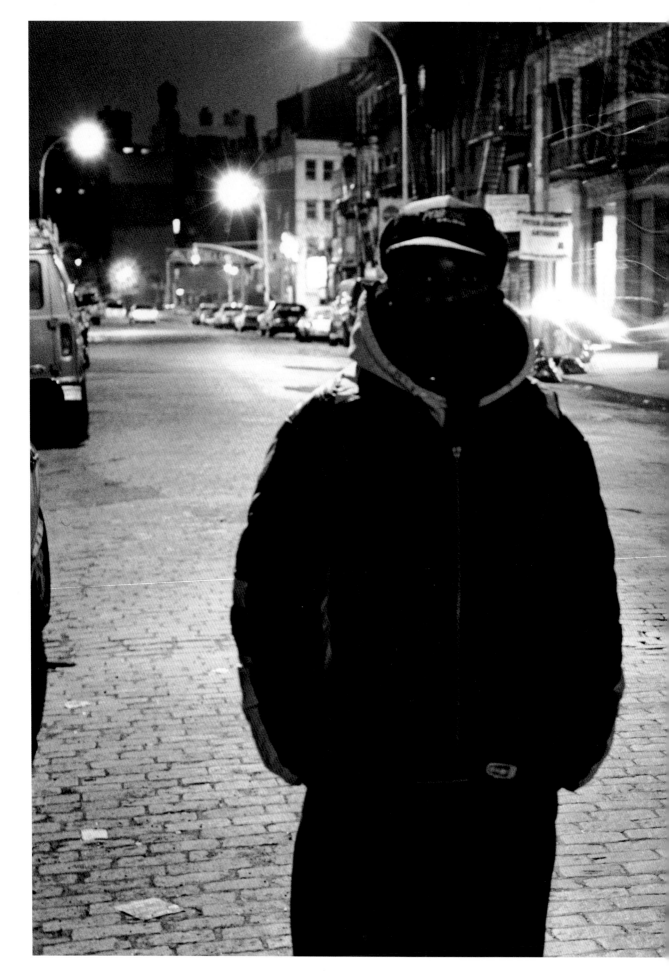

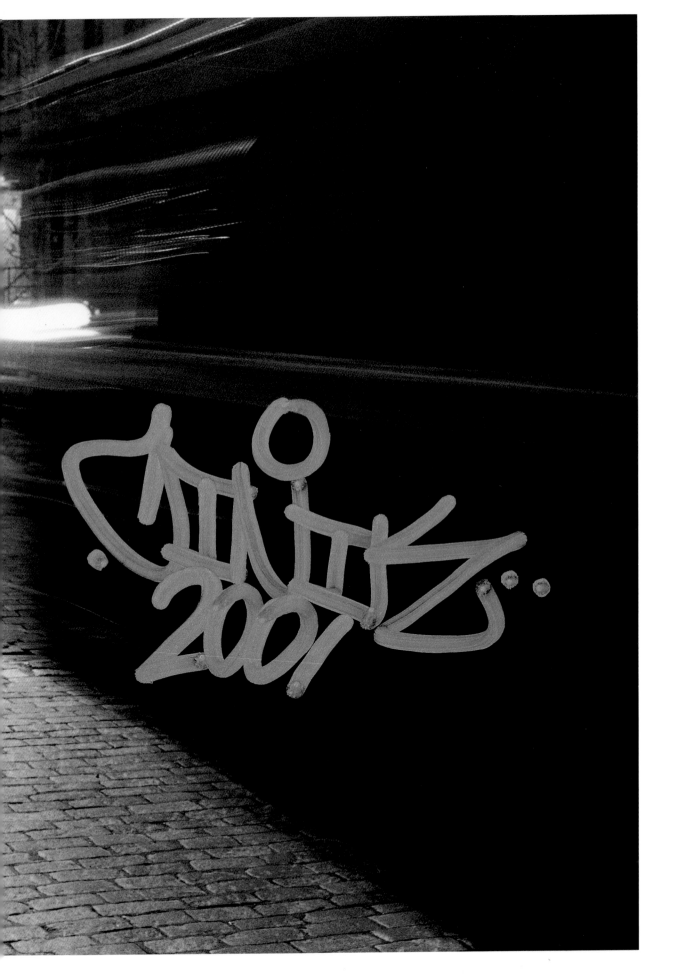

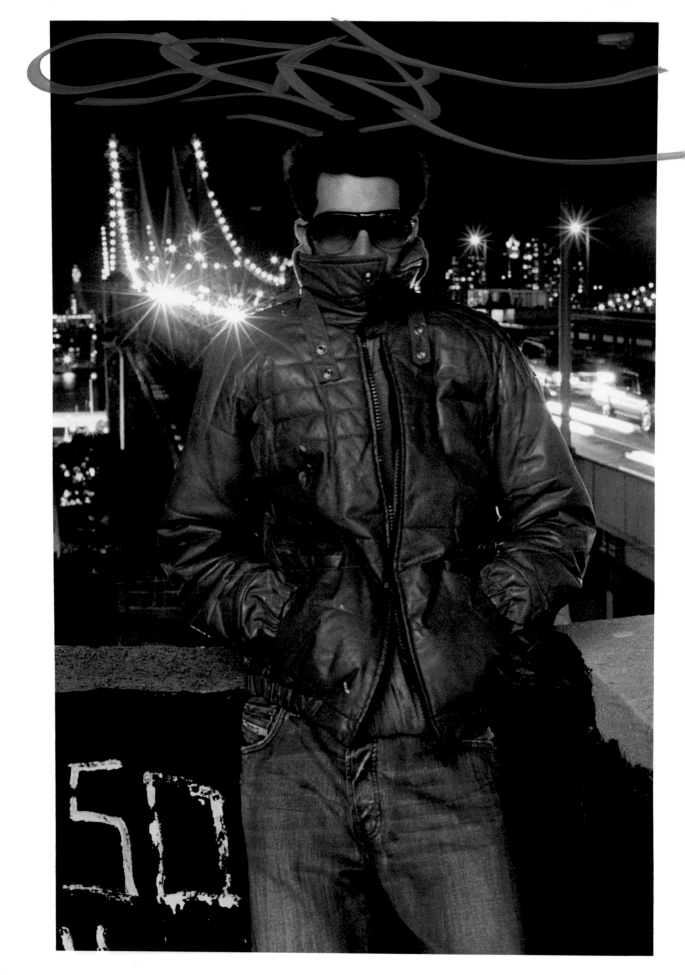

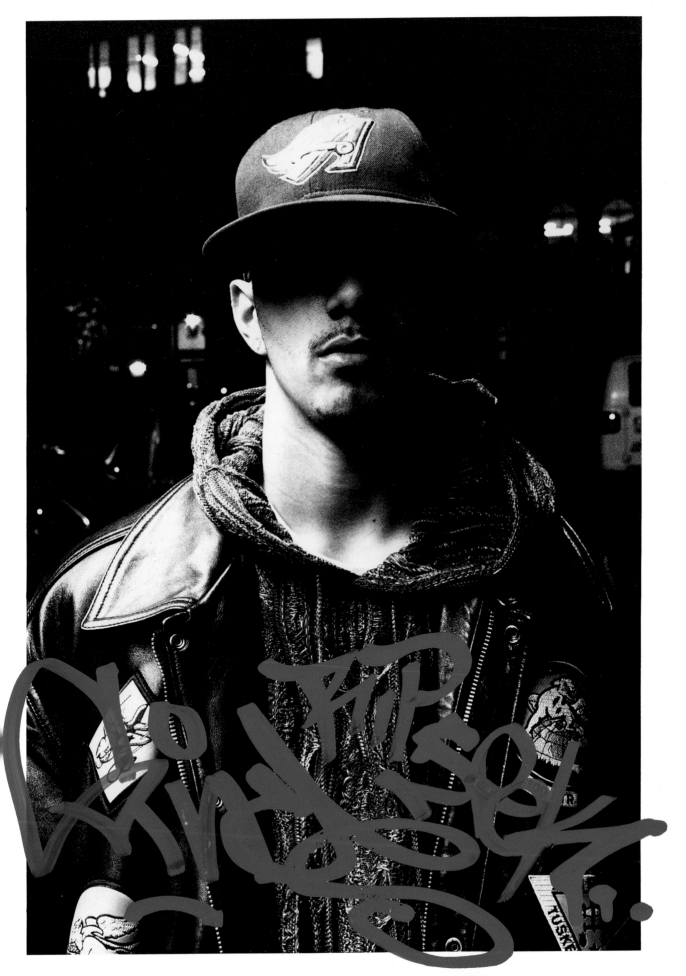

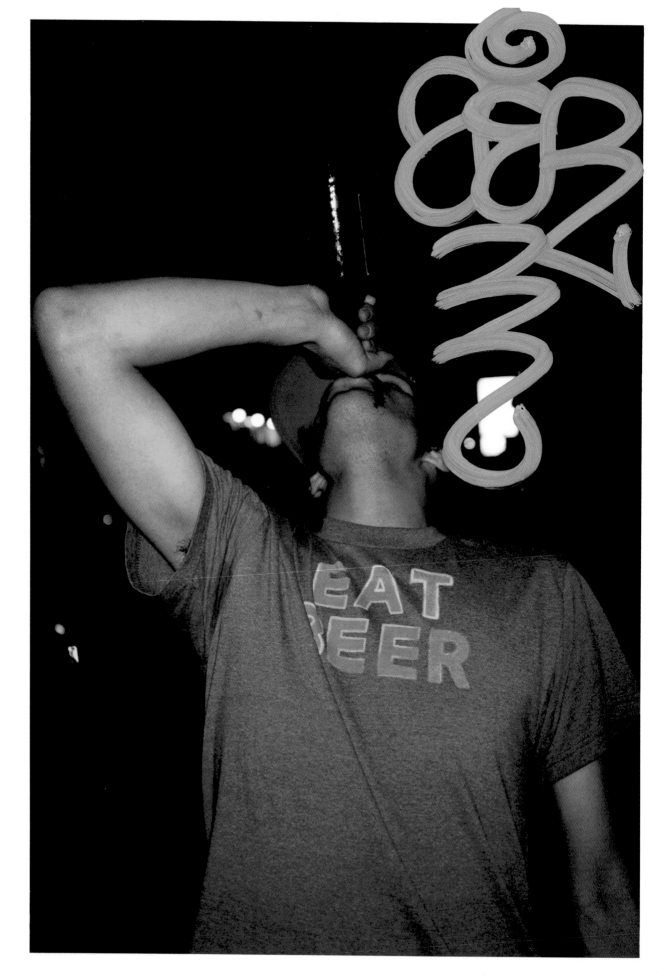

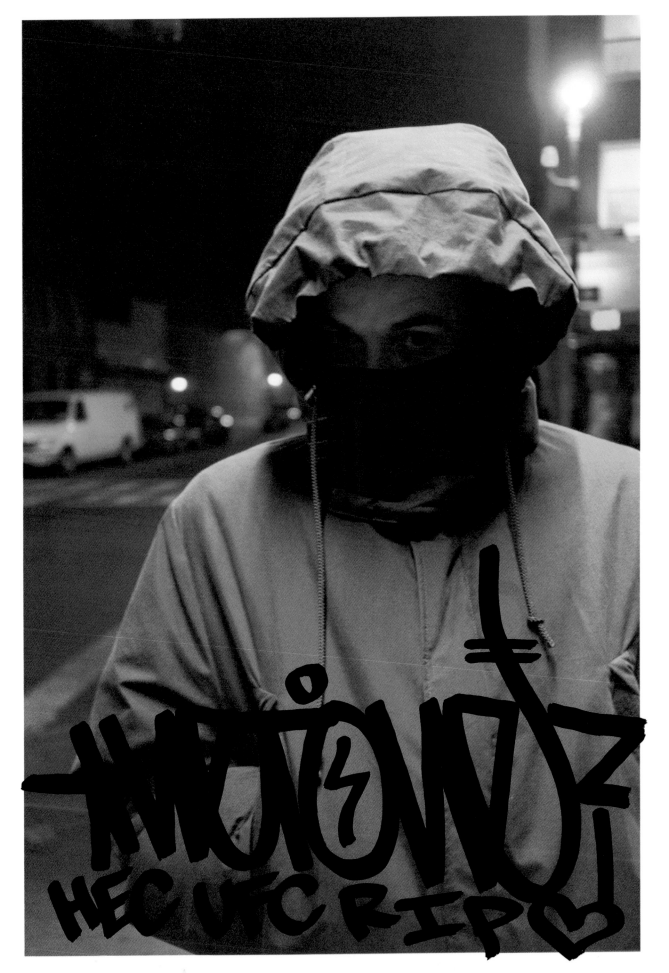

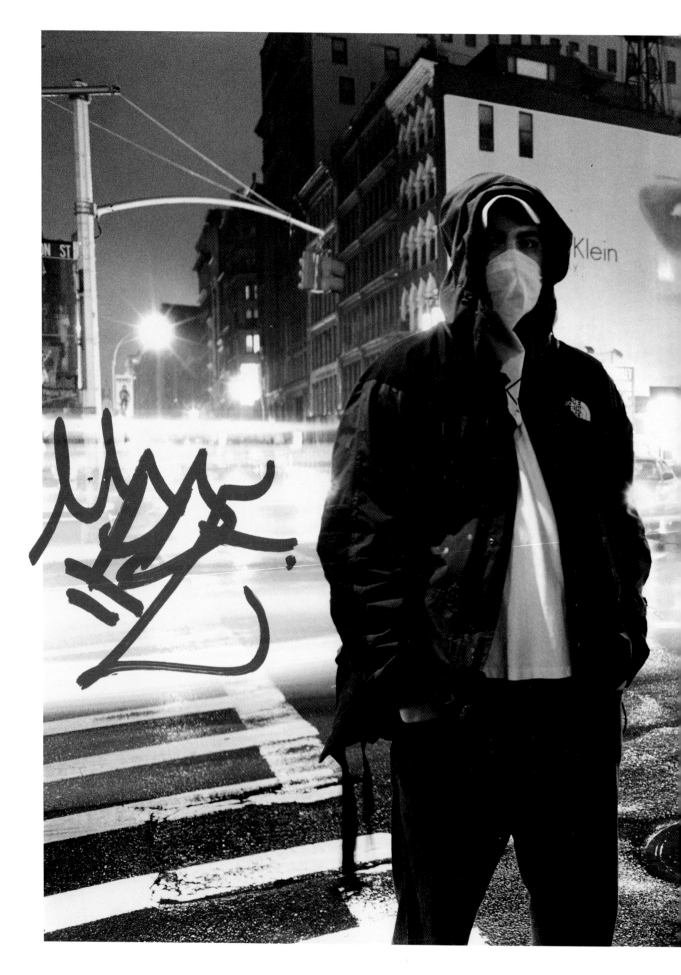

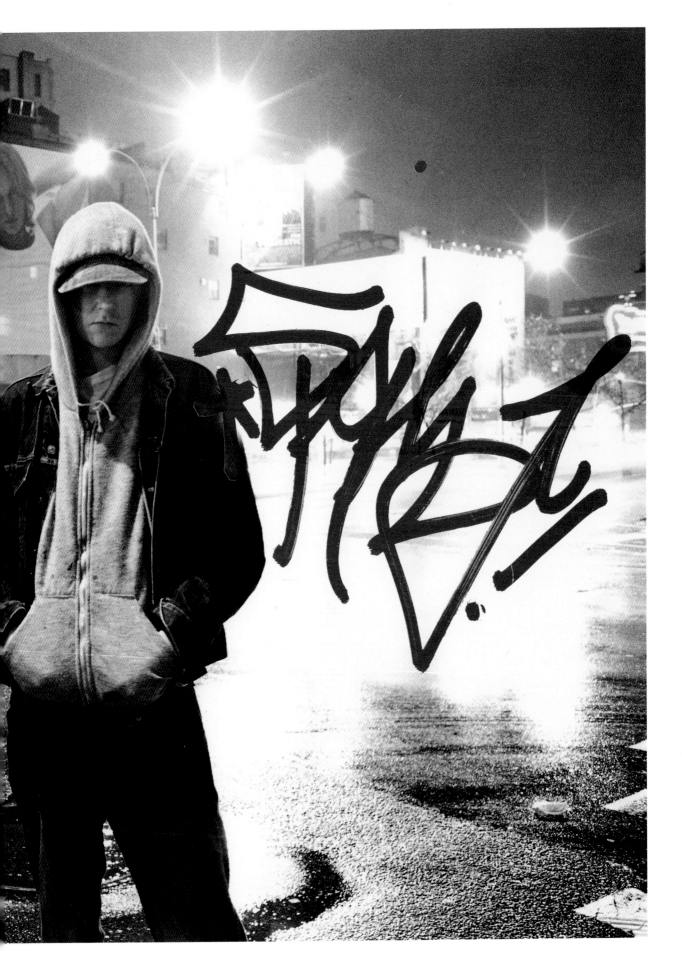

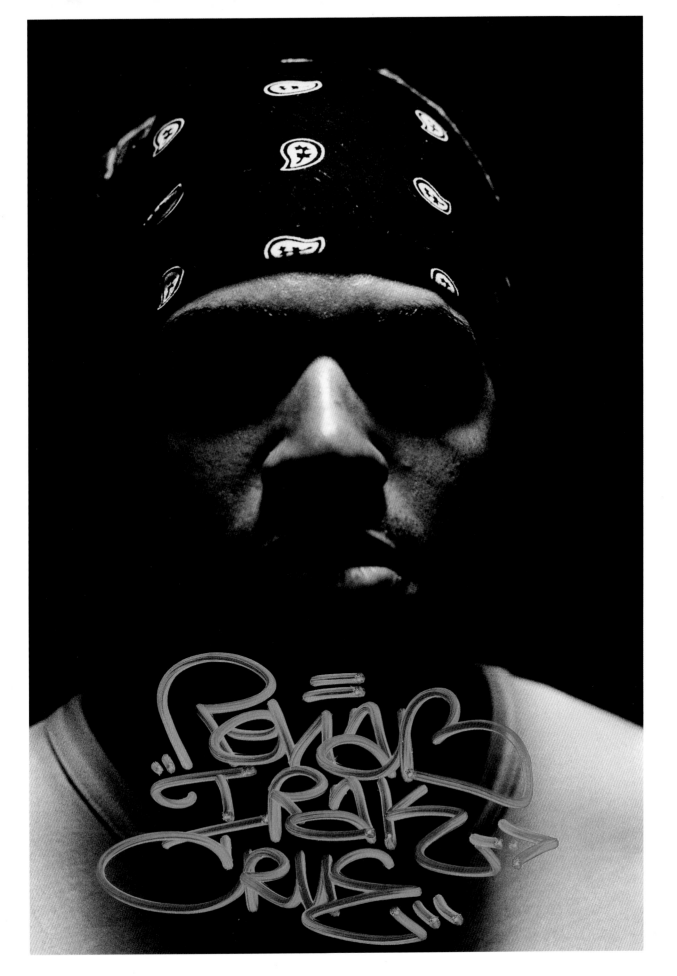

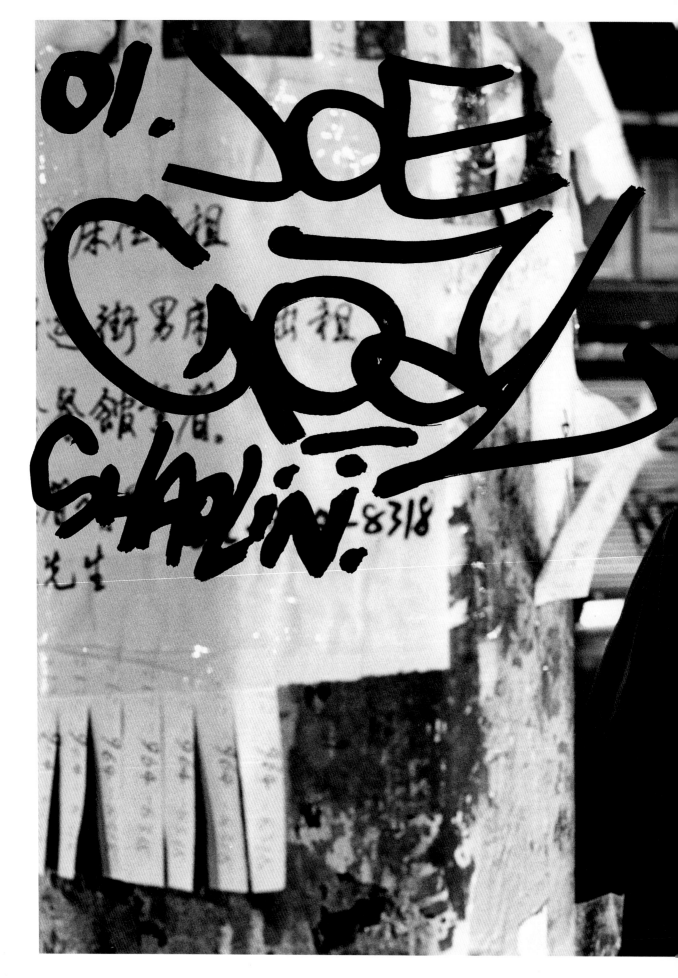

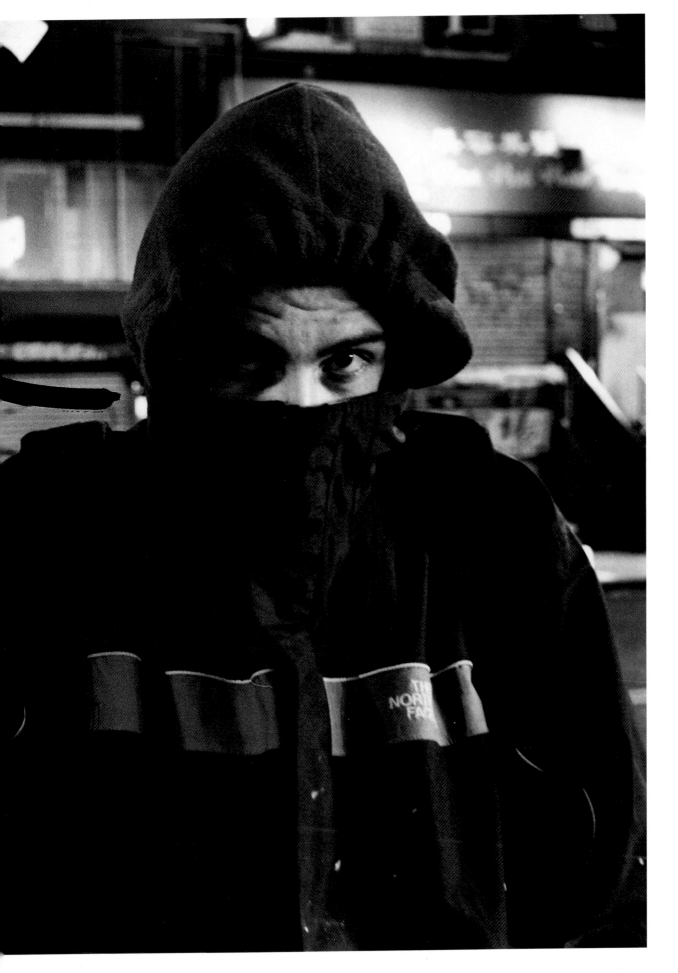

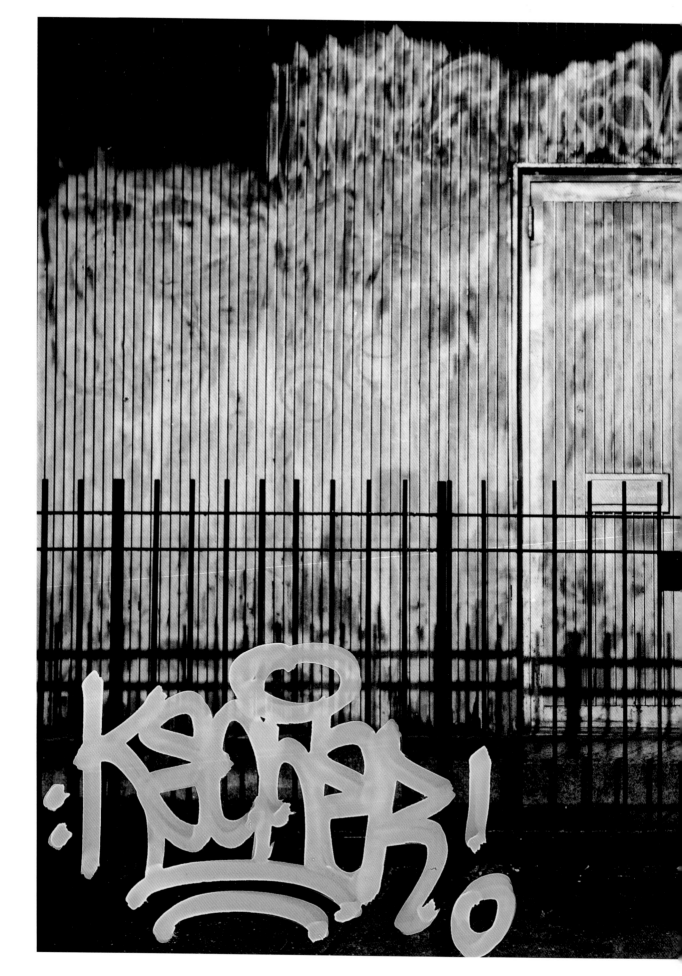

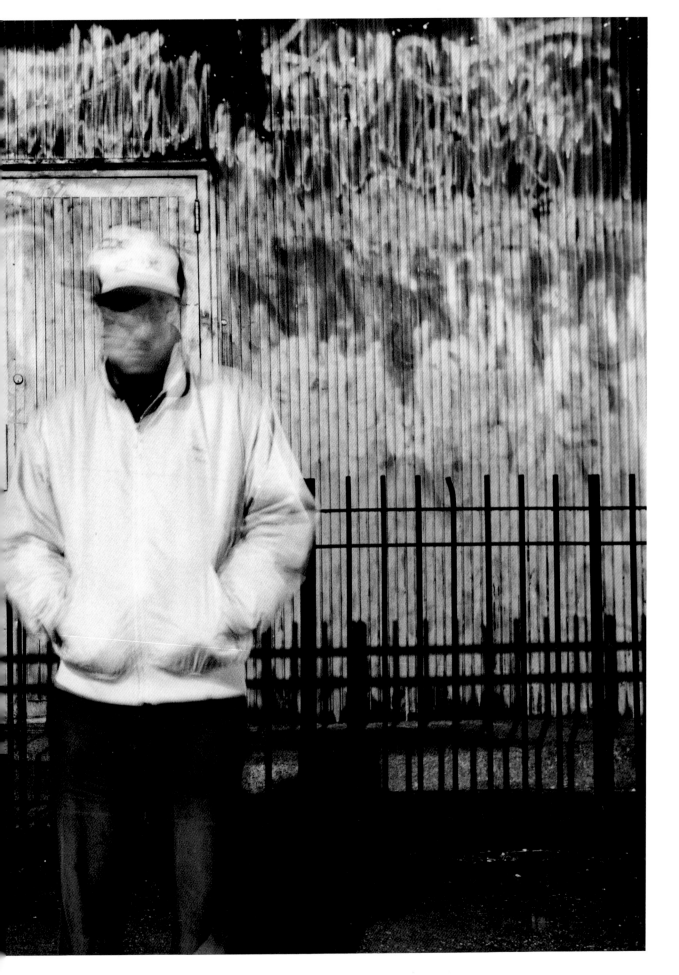

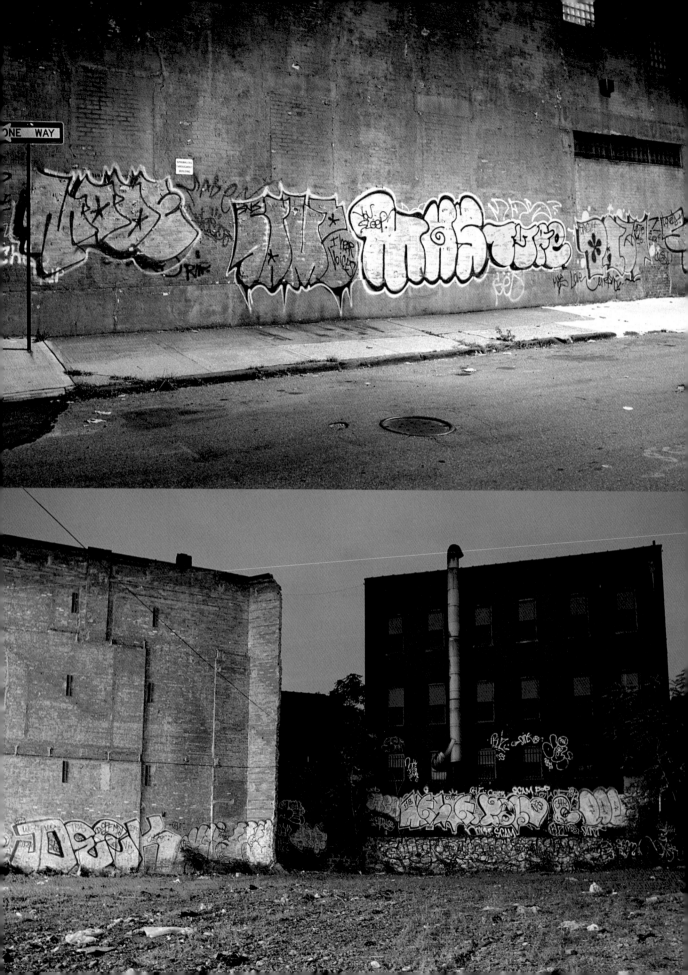

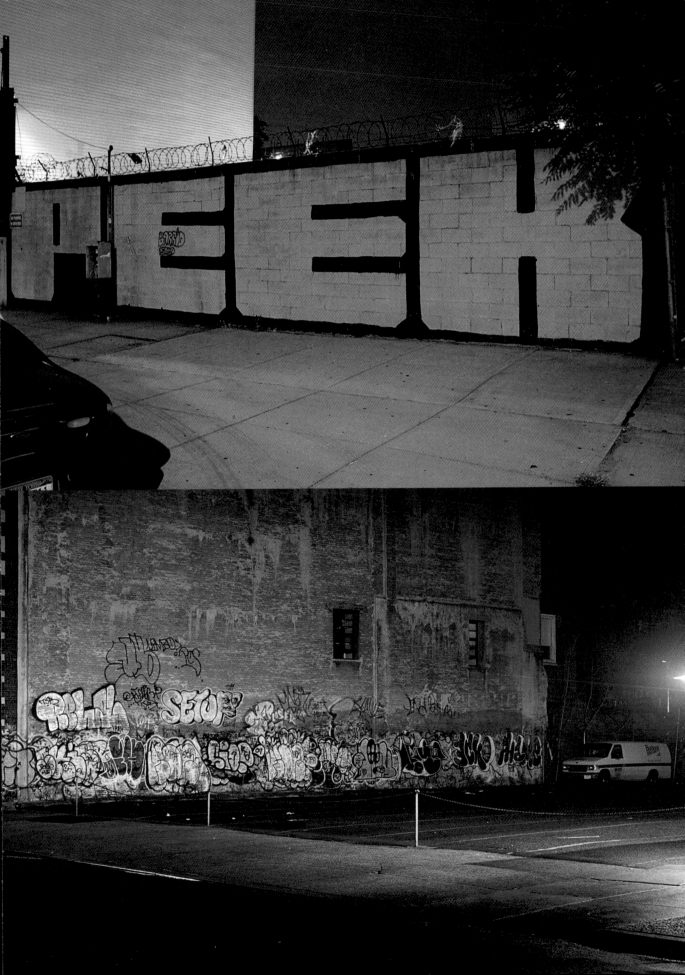

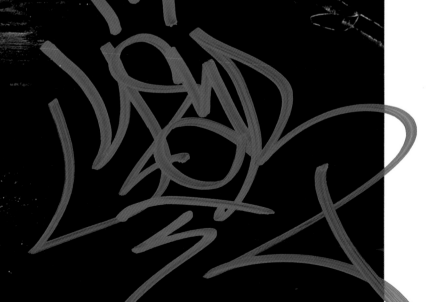

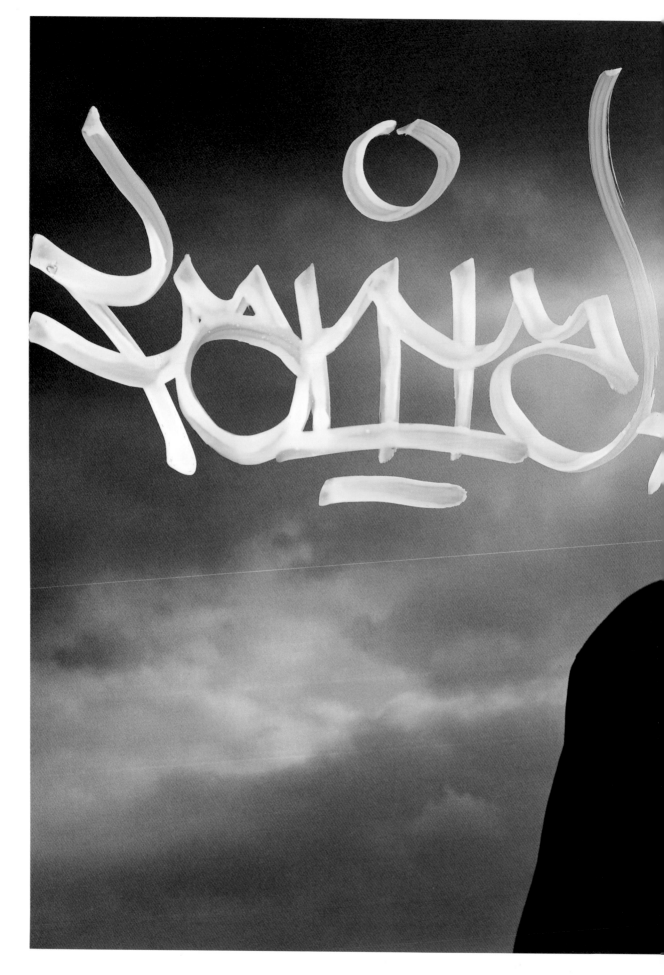

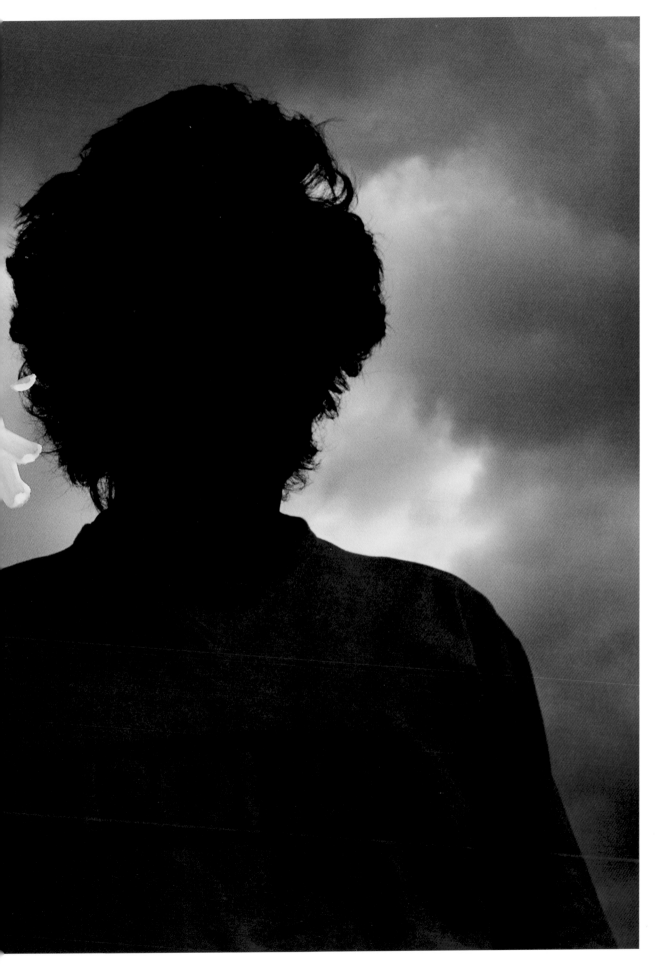

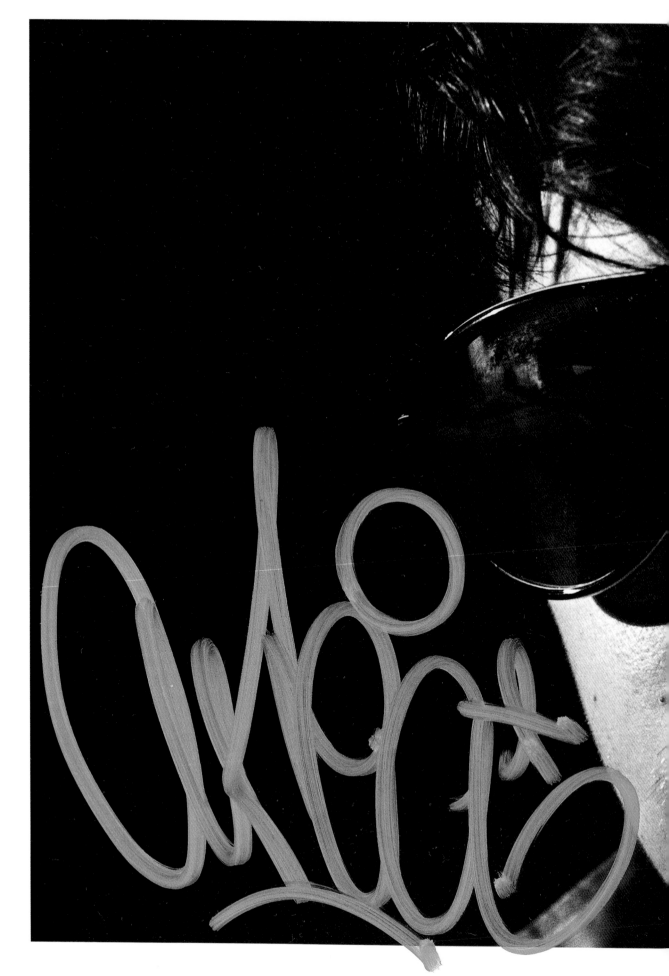

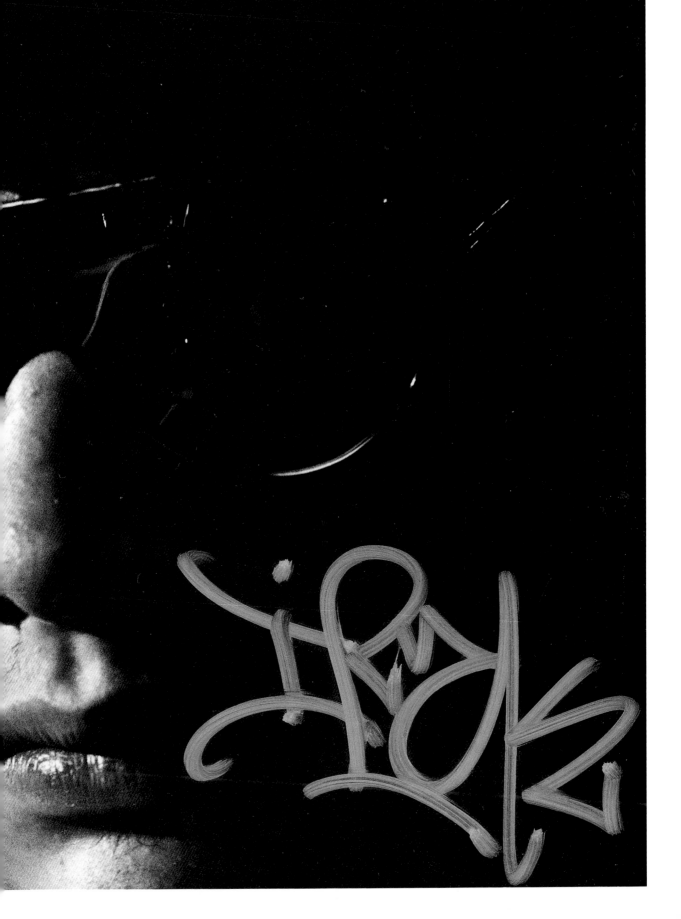

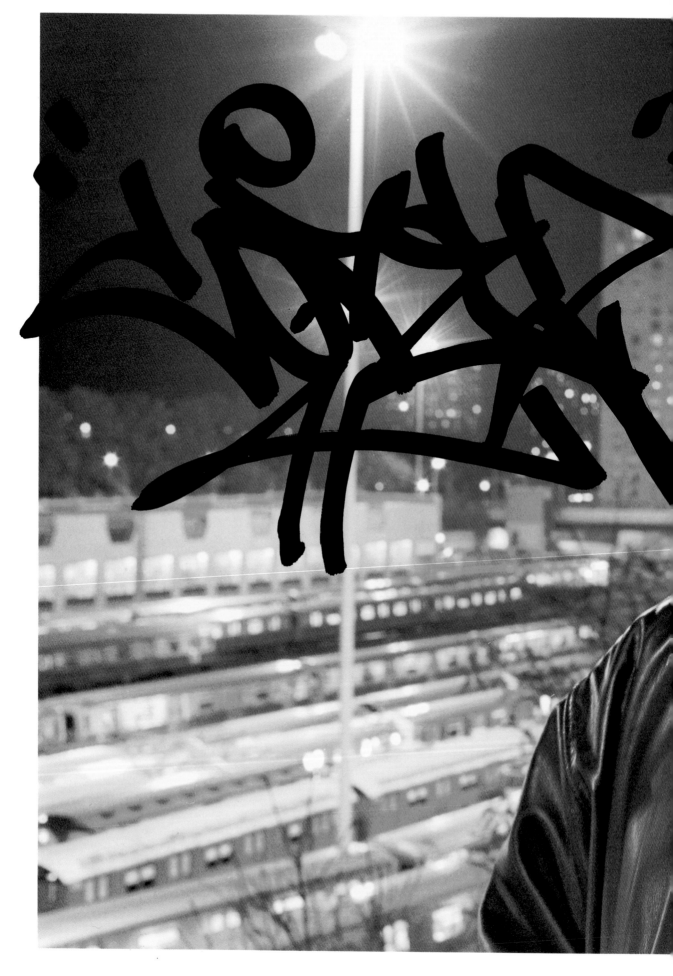

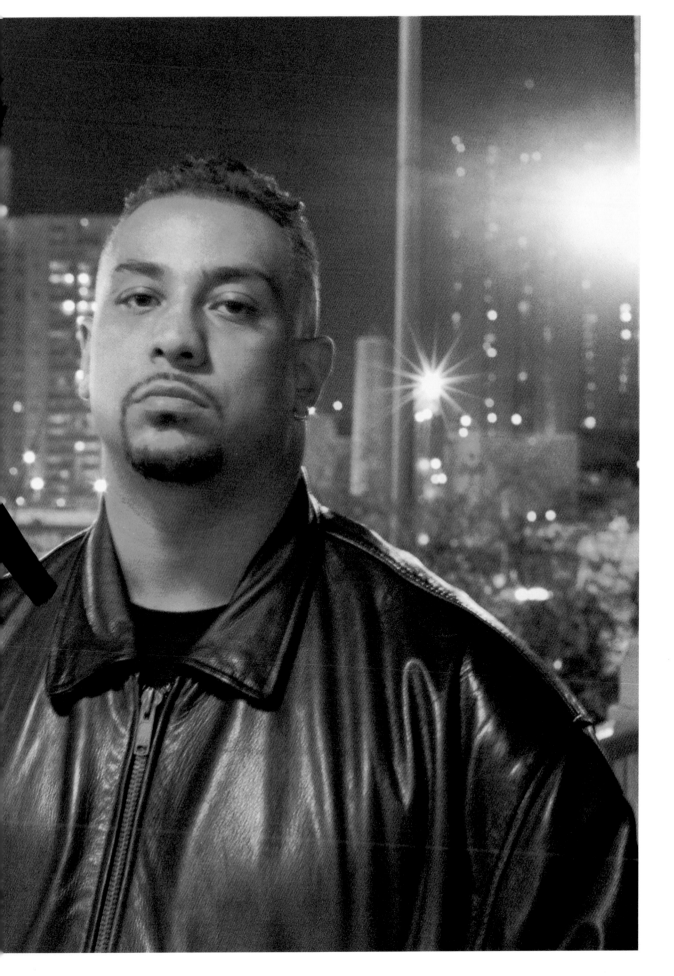

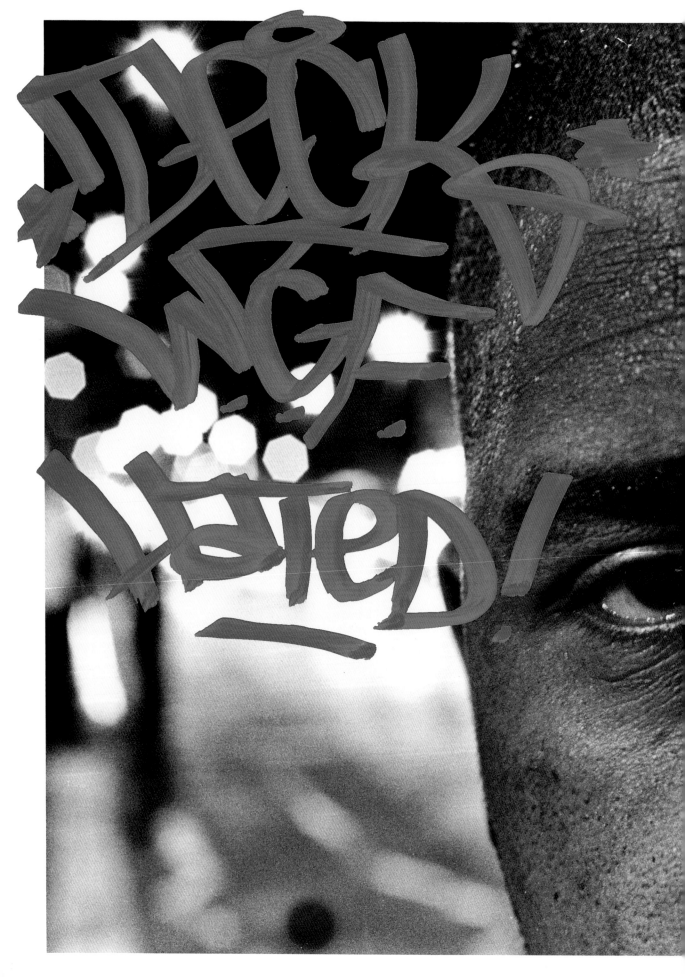

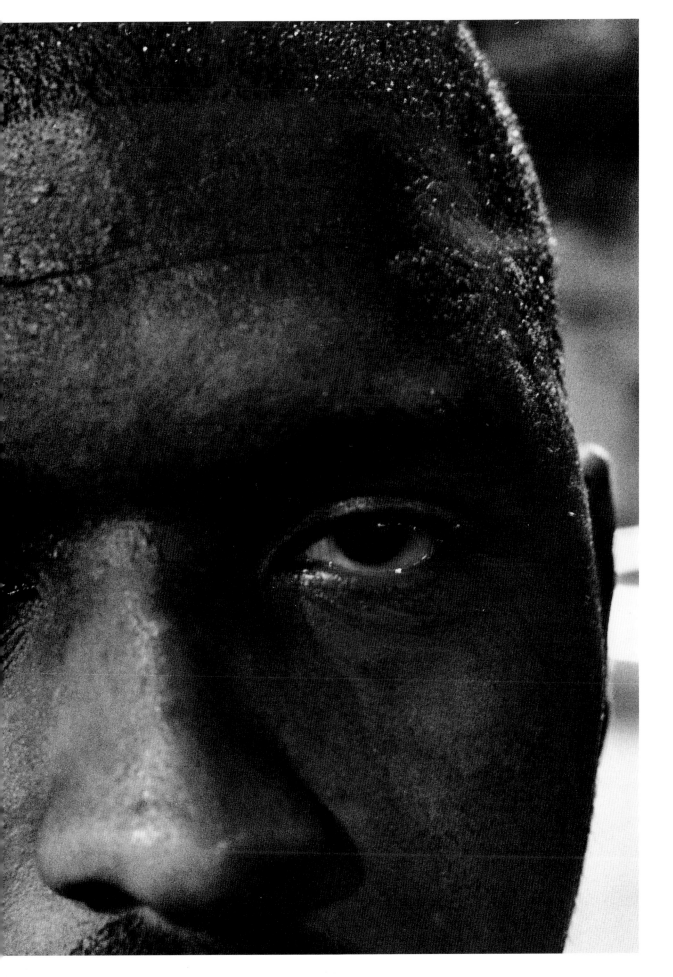

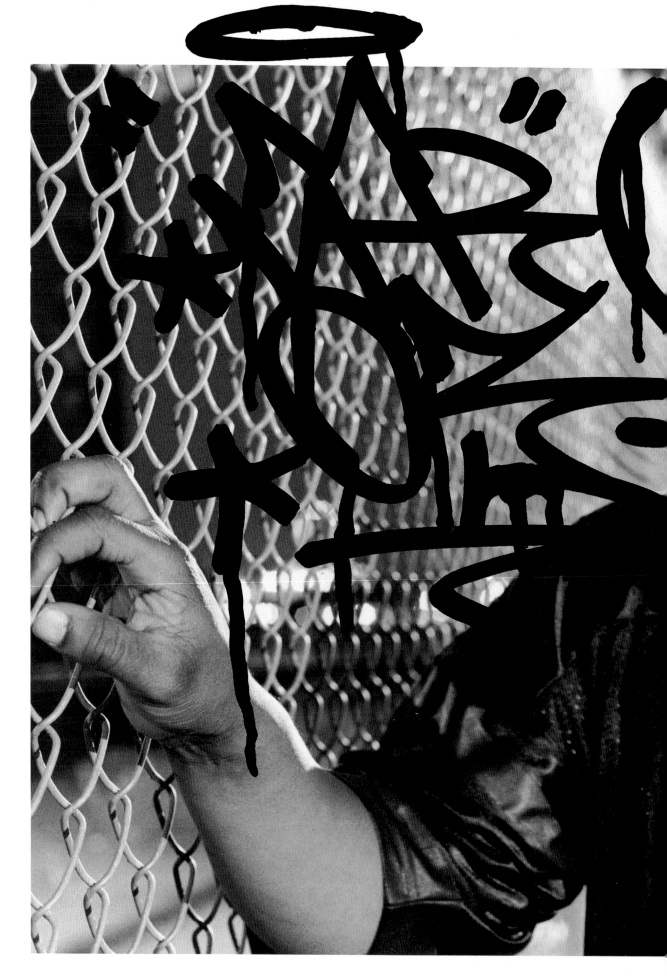

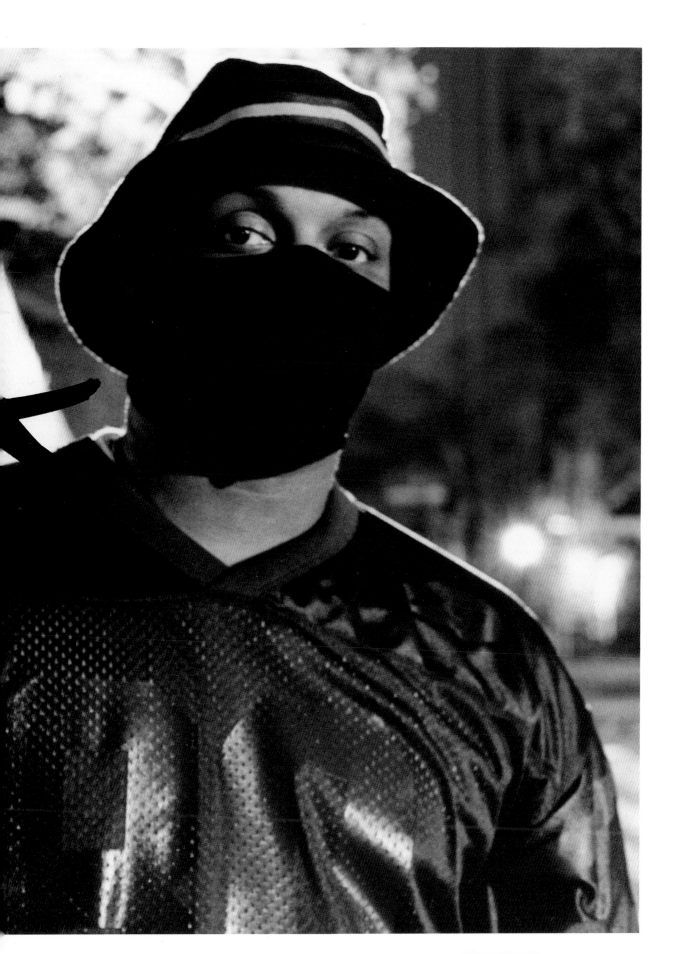

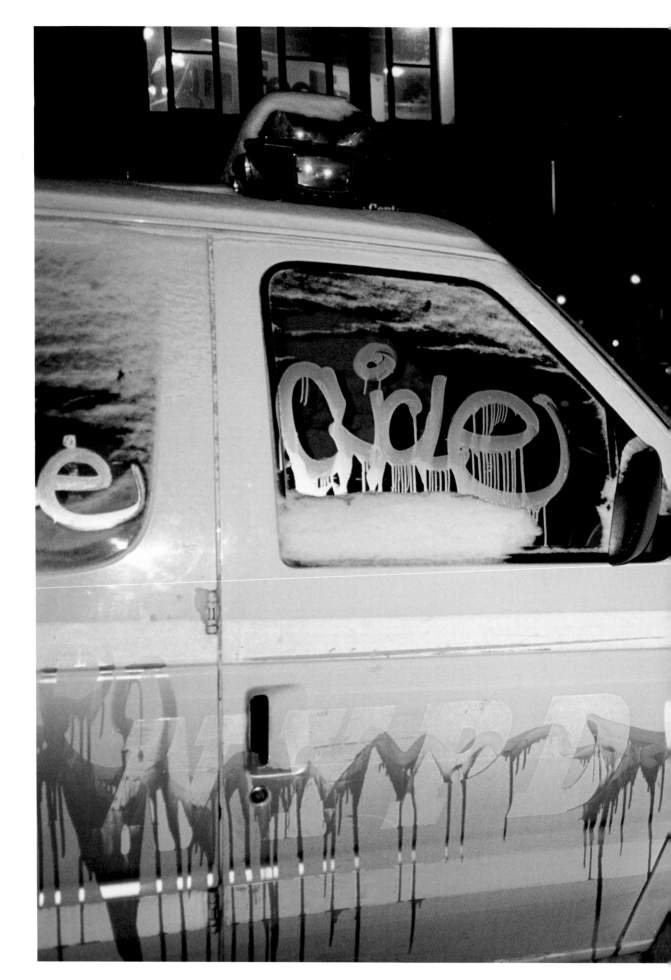

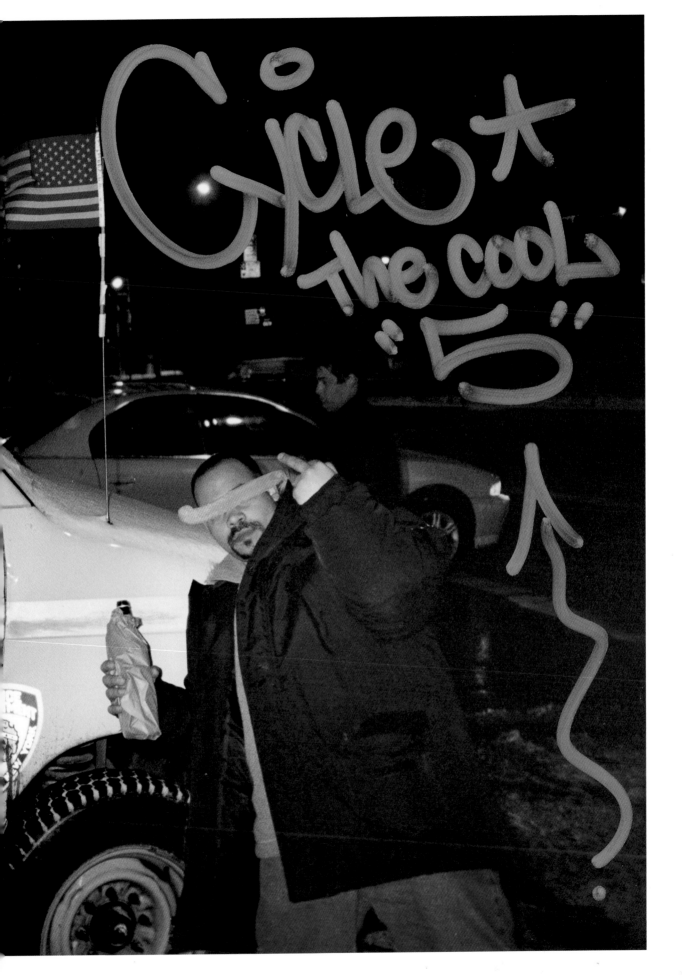

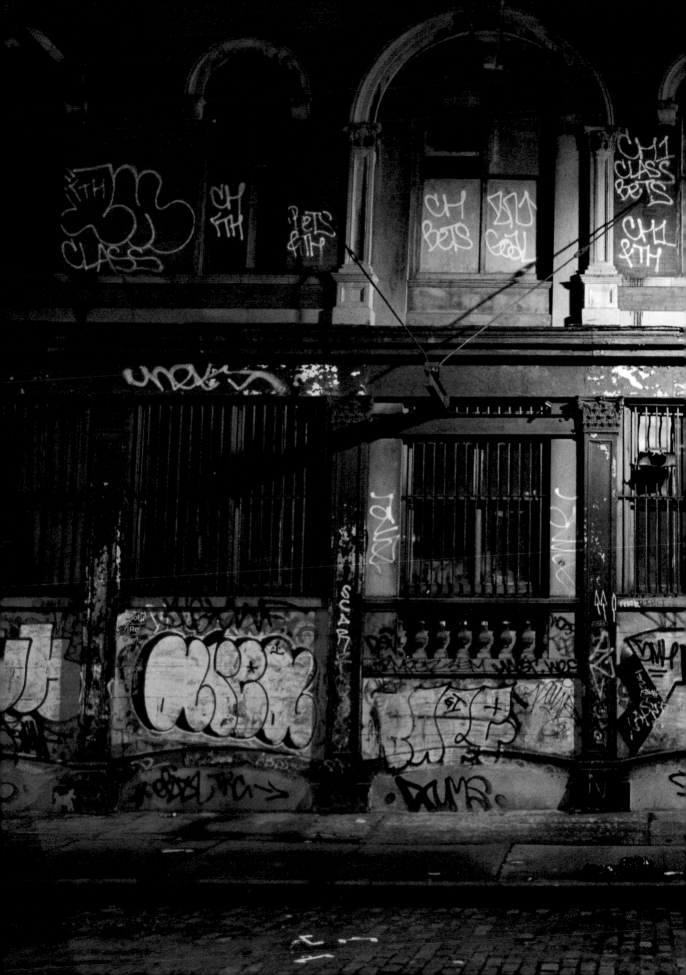

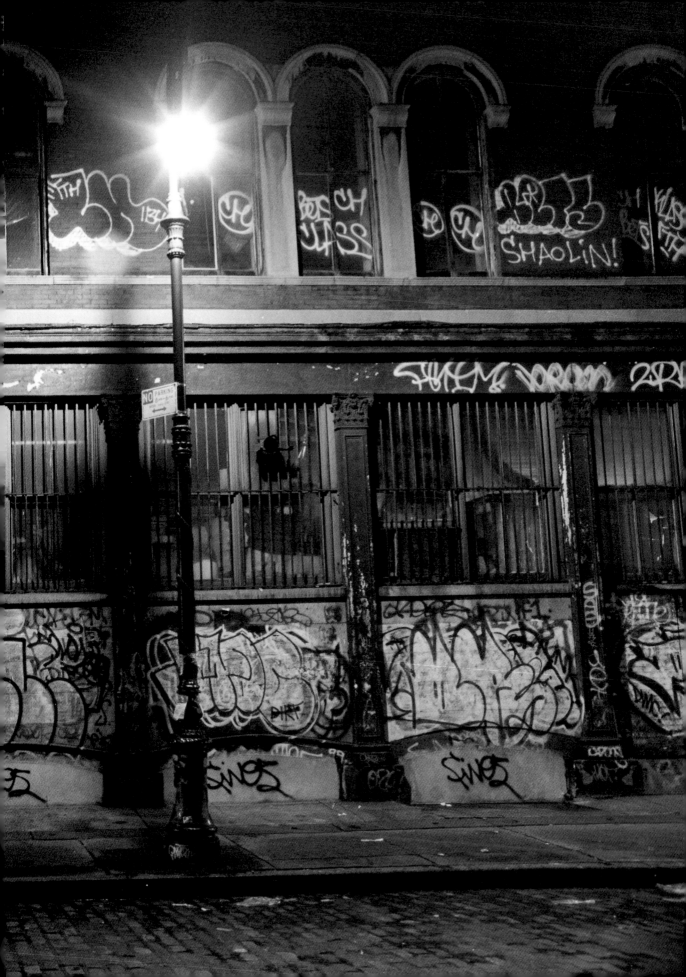

Autograf was photographed in New York City over the course of three years, 2001–2004. It was an honor to meet and work with the people involved with this book.

Thanks to: all graffiti writers pictured, Miss Rosen, Daniel Power, Craig Cohen, Kiki Bauer, Francesca Richer, Gerhard Stochl, Kevin Trageser, Andrew Sutherland, Jan Sutherland, Don and Kim Umphrey, Earl and Evelyn Umphrey, NATO, REVS, PEZ, LASE, CLAW, VFRESH, DSENSE, EARSNOT, SERF, MINT, RD, KEL, 5MH Crew, Alexander Nedo at Die Gestalten Verlag GmbH, Angela Boatwright and Adrian Moeller at *Mass Appeal*, Sarah and Guillaume at colette, Johann Haehling von Lanzenauer at Cc:room (Circleculture Cc:), *LODOWN*, ALIFE, Brian Scotto, Kristi Gamble, Clay Weiner, Taka Kawachi, Ana Lombardo, Matt Clark, Mai Lathai, Angie Lee, Helen Stickler, Linda Lee, Small Dark Room, Diapositive Lab, Silver Warner, PSYOP, Educated Community, Jack Youngelson, Woo Cho, David Leslie, Shepard Fairey, Roger Gastman, Dana Albarella, Patrick McMullan, Charles Peterson, Ari Marcopoulos, José Ortiz, Kristian Orozco, Daniel Buckley, Katherine Aguilar, Emily Power, Jane Catucci, Jamie Hardy.

I dedicate this book to my dad....
Peter Wingate Sutherland (1945–2000).

—Peter Sutherland
New York City, January 2004

Special thanks to Rockstar Games

Peter Sutherland is a filmmaker and photographer who was born in Ann Arbor, Michigan in 1976 and raised in Colorado. A move to New York City in 1998 prompted his first feature documentary, *Pedal*, a film about the city's bike messengers that airs on the Sundance Channel. Sutherland also worked as director of photography on *Stoked: The Rise and Fall of Gator*, a documentary about Gator, a famous skateboarder who was convicted of murder in 1991. Directed by Helen Stickler, *Stoked* premiered at the 2003 Sundance Film Festival, and was released theatrically by Palm Pictures in August 2003. Sutherland is a contributing photographer to magazines including *Vice*, *Tokion*, and *Nylon*, and has done commercial photographic work for Nike and Vice Records. He has shown his work at the Rivington Arms gallery and at 255 Elizabeth Space, both in New York. Sutherland lives and works in New York City.

MERZ
Brooklyn 2001

KR
Brooklyn 2001

323
Brooklyn 2002

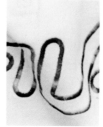
KORN
Manhattan 2002

EWOK
Manhattan 2002

KAWS
Brooklyn 2002

JEST
Manhattan 2002

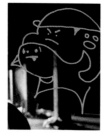
OZE 108
Brooklyn 2003

DONA
Manhattan 2003

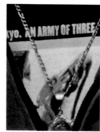
STAY HIGH 149
Manhattan 2002

DOZE
Manhattan 2002

REVS
Brooklyn 2003

CLAW
Manhattan 2003

MYNOCK 21
Manhattan 2001

EARSNOT
Manhattan 2001

SEMZ
Manhattan 2002

KSER
Manhattan 2001

SEMEN
Manhattan 2002

SACER
Manhattan 2001

UFO
Manhattan 2002

PEEK/DIVA
Brooklyn 2002

DSENSE
Manhattan 2002

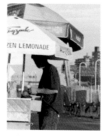
GLACER
Manhattan 2002

NYMZ
Manhattan 2001

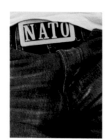
NATO
Queens 2002

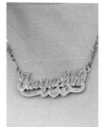
JAKEE
Brooklyn 2002

ARTZ
Manhattan 2001

MUK
Brooklyn 2002

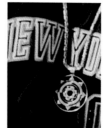
LASE
Manhattan 2002

LADY PINK
Queens 2003

MOSCO
Manhattan 2002

FUTURA
Brooklyn 2002

GEN 2
Brooklyn 2002

PEZ
Manhattan 2001

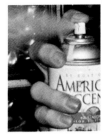

SARE
Manhattan 2001

RATE
Manhattan 2002

MINT
Manhattan 2001

CINIK
Manhattan 2001

SERF
Manhattan 2001

SINCE
Manhattan 2002

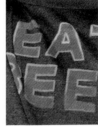

ZER
Manhattan 2003

NET
Brooklyn 2002

MADE/SAME
Manhattan 2002

REHAB
Manhattan 2002

GOAL
Manhattan 2001

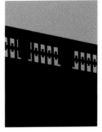

KECH
Manhattan 2002

YEAR
Manhattan 2002

FANTA
Manhattan 2001

AREA
Manhattan 2001

COPE 2
Bronx 2002

DECK
Manhattan 2002

VFRESH
Manhattan 2002

CYCLE
Manhattan 2002

New York City's Graffiti Writers

Published in the United States by powerHouse Books, a division of powerHouse Cultural Entertainment, Inc. 68 Charlton Street, New York, NY 10014-4601 telephone 212 604 9074, fax 212 366 5247 e-mail: autograf@powerHouseBooks.com website: www.powerHouseBooks.com

Library of Congress Cataloging-in-Publication Data:

Sutherland, Peter, 1976-
 Autograf : New York City's graffiti writers / photographs by Peter Sutherland ; text by by Revs.
 p. cm.
 ISBN 1-57687-203-3 (Hardcover)
 1. Mural painting and decoration, American--New York (State)--New York--20th century. 2. Street art--New York (State)--New York. 3. Graffiti--New York (State)--New York. I. Revs. II. Title.

 ND2638.N4S85 2004
 751.7'3'097471--dc22

 2003024830

Hardcover ISBN 1-57687-203-3

Separations by Amilcare Pizzi, S.p.A. Milan
Printing and binding by Lotus Printing, Inc.

Project Manager: Miss Rosen

Art Direction: Francesca Richer, Kiki Bauer
"Autograf" Tag by EARSNOT

A complete catalog of powerHouse Books and Limited Editions is available upon request; please call, write, or get up on our website.

10 9 8 7 6 5 4 3 2

Printed and bound in Singapore

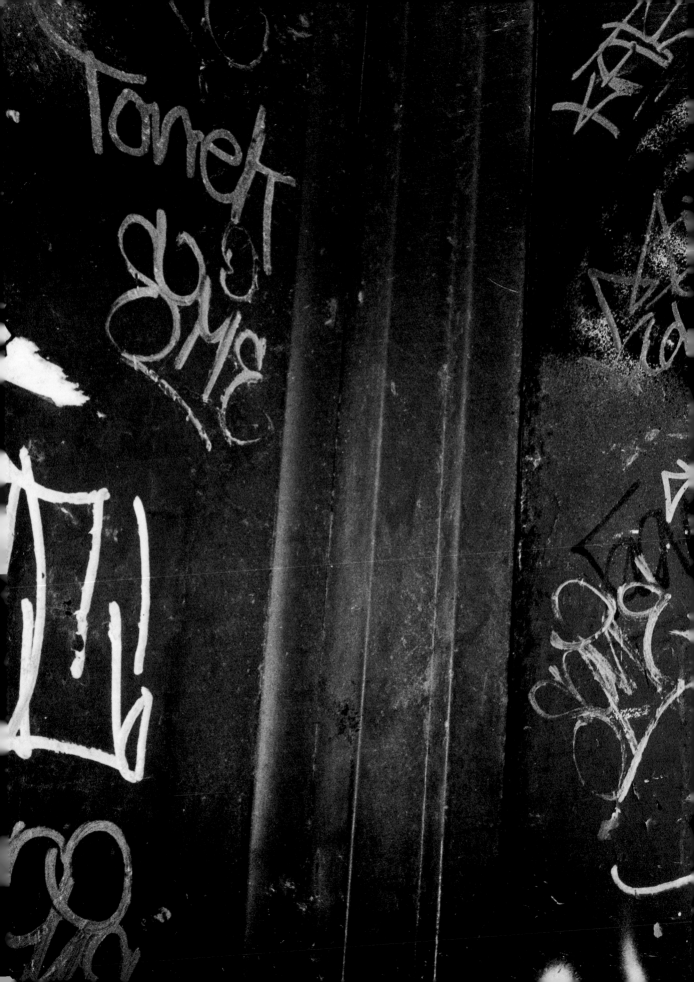